American
Primitives
in Needlepoint

Books by Brande Ormond

Needlepoints to Go:
Small Projects for Spare Moments

American Primitives in Needlepoint

American Primitives in Needlepoint

by Brande Ormond

Houghton Mifflin Company Boston 1977

To my parents,

Tom and Elaine,

who persistently keep the faith

Library of Congress Cataloging in Publication Data
Ormond, Brande.
 American primitives in needlepoint.
 1. Canvas embroidery — Patterns. 2. Primitivism in
art — United States. I. Title.
TT778.C3074 746.4'4 77-8277
ISBN 0-395-25485-X

Printed in the United States of America

M 10 9 8 7 6 5 4 3 2 1

Acknowledgments

Many thanks to Judy Gordan, Beka Martin, Betty McDonnell, Elaine Ormond, Alberta Saletan, Frances Tenenbaum, and Ina Zoob for the beautiful work they did on the needlepoint samples for the photographs. Thanks to Sona Johnston, at the Baltimore Museum of Art, Sian Jones at the Walters Art Gallery, Michael L. Heslip, and Ken Moore for their kind assistance.

My deepest appreciation to Billie Conkling, for graciously supplying all the materials used in the needlepoint samples from her super shop in Ruxton, Maryland.

The color photographs are by Bill Buie, whose talent, enthusiasm, and PATIENCE made this difficult job a pleasure, and I thank him!

Finally, I want to express very special thanks to my mother, Elaine Ormond, my dear friend, Carol Smith, and my editor and friend, Frances Tenenbaum, for their support and understanding.

Contents

Primitive Art: What's It to You?

Primitive paintings have an interplay of texture and pattern, bright colors, and a distinctive linear quality that have recently attracted present-day artists as well as appreciators of art and those interested in this country's history. Because of the similarities of primitives to current styles of painting, we are beginning to realize how beautifully they blend into any décor, whether traditional or contemporary. These paintings will add warmth and charm to any room in your home . . . or to that of a lucky friend.

It is my belief that needlepoint should be utilitarian rather than merely decorative. There are many interesting uses for these designs; they can be made into personal items, like handbags, tote bags, and small pieces of luggage, or they can be pillows, bench tops, chair seats, fire screens, and telephone-book covers for your home. However, if you do hang your needlepoint, I hope that you will not insult it by putting it under glass, especially after you have gone to all the trouble of using yarn and canvas of excellent durability.

The shape of a painting should be similar to that of the object the needlepoint is to be used for. But you can alter the shape somewhat by extending the background or adding a border or two from the ones you will find in the back of this book. Although the graphs have different numbers of stitches, any of them can be made larger or smaller depending on the gauge of the canvas you use. In other words, small-gauge canvas yields a small design, and large-gauge canvas will give you a larger design. Almost any of the designs in the

book could be made into a small hearth rug if you use #5 gauge canvas. There is a chart with each graph that will tell you the approximate size of the design you will get from each of the recommended canvas gauges.

It's important to have a plan for your needlepoint so that you can determine accurately what size to cut your canvas. If this isn't possible, you should include a generous allowance of several extra inches on each side of the canvas for any extra rows of stitches you may want to add later. Failing this, it's always possible to extend a finished canvas with a border of some heavy fabric, like velvet or corduroy. Remember that none of the thread counts for the graphs includes any extra rows of stitches for seam allowances, so if you are planning to make something that needs to be turned under, you must work three or four extra rows on each side. A knife-edge pillow (that is, one mounted without boxing) will need at least five or six additional rows to prevent loss of the design where the pillow slopes into the seam.

You will certainly think of many uses for these designs other than the ones suggested above. Just keep in mind that needlepoint is rugged and washable, and that a worked canvas is essentially a fabric that can be substituted for almost any other heavy fabric.

Supplies

The success of your finished product and the amount of pleasure you derive from the work depend on the quality of the materials you begin with. So don't skimp — learn to recognize and insist on the best. When you think what you'd have to pay for these designs if they were hand-painted, you'll realize that with the money you can save on one canvas by using this book you can spend the few extra dollars and still come out way ahead.

The following materials can be found in needlework specialty shops throughout the country.

You are probably already familiar with Paternayan Persian wool. Although it was originally imported for the repair of Persian carpets, it soon became the favorite of canvas embroiderers because of its magnificent color range and durability. It comes in strands comprised of three plies, which can be separated for use on different canvas gauges. There are now "Persian-type" yarns available, but this book deals only with the wool from Paternayan. When you buy wool for your project, ask for the colors by the numbers listed in the book. Some shops sell this wool by the strand, but many won't sell less than an ounce of a color; if this is the case with the shop you patronize, take your bag of scraps (if you have one) and use the color chart to help you choose substitutions. Don't be terribly concerned if you must buy more than you need; a good selection of scraps is an invaluable asset to the serious needle-pointer. Because it's difficult to estimate quantities accurately, it's best to rely on the experience of your salesperson to help you judge the amount of each color you'll need.

Needlepoint canvas comes in single (mono) or dou-

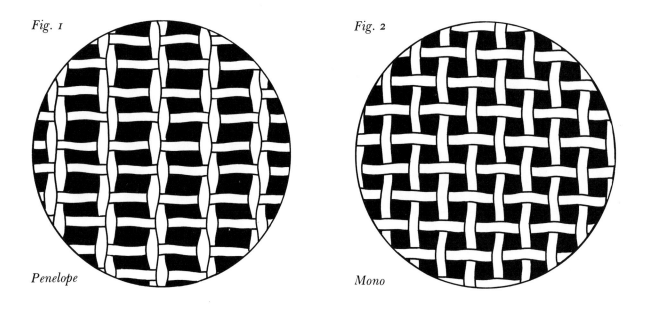

Fig. 1

Fig. 2

Penelope

Mono

ble (penelope) meshes, and is available in a variety of gauges (threads per inch) and in widths from 36 to 60 inches. The best canvas has a hard, smooth finish and an even twist with no obvious irregularities. If a canvas is shiny or feels rough, don't accept it; the sizing is likely to give up quickly, leaving you with a frustrating mass of limp canvas threads. Look for canvas that comes from France or West Germany, and always check your piece for flaws in the weave. Except for #5 canvas, which is a double-mesh canvas, I recommend the following gauges in mono for the best coverage:

Canvas Gauge	Threads of Persian Yarn
#18	one
#14	two
#10	three (whole strand)
#5	three strands (9 threads)

The best needles come from England; use only blunt-ended tapestry needles for needlepoint. You can use whatever size is comfortable for you so long as you can thread the needle easily and it slides through the canvas without a tug. The recommended sizes are:

Canvas Gauge	Needle Size
#18	#22
#14	#20
#10	#18
#5	"Quick Point" needle

You will also need a pair of small embroidery scissors, the kind with fine, sharp points that enable you to clip with accuracy in tiny areas. If you use a thimble for needlepoint, make sure it has no raised decoration that might snag the wool.

Good lighting is supremely important. The ideal is indirect sunlight, but since many of us can stitch only at night, remember that you can obtain a similar light by using both fluorescent and incandescent lamps together. If you can't do that, aim the strongest, whitest light you have directly at your work. Luxo makes an inexpensive, clip-on, adjustable lamp that takes up to a 100-watt bulb. The light should come over your left shoulder if you are right-handed, and over the right shoulder if you are left-handed.

Except for the bias tape, the supplies described next can all be found in stationery and art supply stores.

You can bind the raw edges of the canvas with 1-inch-wide masking tape, or you may prefer to sew on bias binding, available at any sewing-notions counter. Assemble a pencil with a hard lead (4H), a kneaded eraser, and a ruler. For marking the grid on the canvas, you will need either a Sharpie brand felt-tip marker in black or brown, or Liquitex brand acrylic paint and a #1 sable watercolor brush. The difference between these means for marking will be explained in a later chapter. You may want a set of colored pencils; its use will also be explained later. A stationer will have small tags on strings; they are useful for labeling hanks of wool.

The Canvas: How to Cut It

Once you know which painting you want to do first, and what you want to make with the finished needle-point, you can begin by figuring the gauge and the size of the canvas you need. For help in doing this, refer to the list of information given with each graph. You will see at a glance how many stitches there are in the graph, horizontally and vertically. You'll also find a chart that gives the size *in inches* for each of the recommended canvas gauges. If you were to count 144 stitches across and 104 stitches down on #10 gauge canvas, you would be measuring off approximately 14¼ inches by 9¾ inches. The larger the canvas gauge you use, the larger the piece will be. By the way, if the equation of the stitch count to the inches on the canvas seems a little off to you, it's because most canvases — both mono and penelope — have a slight difference in the number of threads per inch running parallel to, and at right angles to, the selvage. The selvage is the woven, finished edge that runs along both sides of the bolt of canvas. Always be sure your canvas is cut with the selvage to the right and left, not top and bottom. This is particularly important with penelope, whose threads running parallel to the selvage are actually woven closer together. (See Fig. 1.)

But don't cut anything yet. No matter what you plan to make with the finished canvas, you'll need to allow for a margin of at least 2 inches on each side of the canvas for binding and handling. If you want to make something that will require an additional allowance for tucking in or turning under, you must remember to add ¼ inch to ½ inch to the 2-inch margin

on each side. Thread counts and widths in inches are
included with each of the counted border designs, and
if you want to use one of these designs, add the mea-
surement of the appropriate gauge canvas to each side.
Here is an example of how your figures would look if
you wanted to cut a piece of canvas for a pillow with a
border:

14½ inches	× 9¾ inches	Dimensions of graph
6 inches	6 inches	Counted border (3 inches for each side)
½ inch	½ inch	Seam allowance (¼ inch for each side)
4 inches	4 inches	Margin of blank canvas (2 inches for each side)
25 inches	× 20¼ inches	Size to cut the canvas

When the canvas has been cut to the proper size, you'll
need to bind the raw edges to keep them from snag-
ging the yarn as you work and to prevent the canvas
from unraveling. Either fold masking tape over the
edges and flatten it down with a smooth part of your
scissors, or sew bias binding around the edges, using a
wide zigzag stitch if your sewing machine has one. If it
doesn't, the bias tape will hold better if you stitch
around it several times, not just once.

The Stitch
and Its Representative

The relationship of the stitch on canvas to a square on a graph is not the mystery some people seem to think. A stitch is the wool that covers a pair of intersecting canvas threads. It is represented by a symbol *contained within* a square on the graph (Fig. 1). Very simple. The lines of the graph do not correspond directly to the threads of the canvas; however, the square space of the graph is intended to represent, abstractly, the *intersection of threads* on the canvas.

Fig. 1

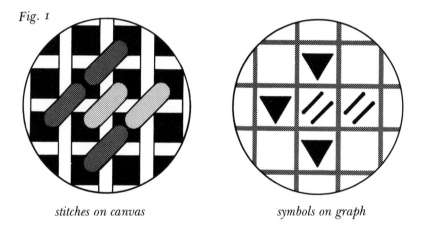

stitches on canvas symbols on graph

The Grid: How to Draw It

Look at any graph in this book and you will see that every tenth line is just a bit heavier than the others. You will also note that each graph is divided in the center, both horizontally and vertically, along one of these accented lines. You should draw a corresponding network of lines on your canvas to aid you in counting stitches. This network of lines is called the "grid."

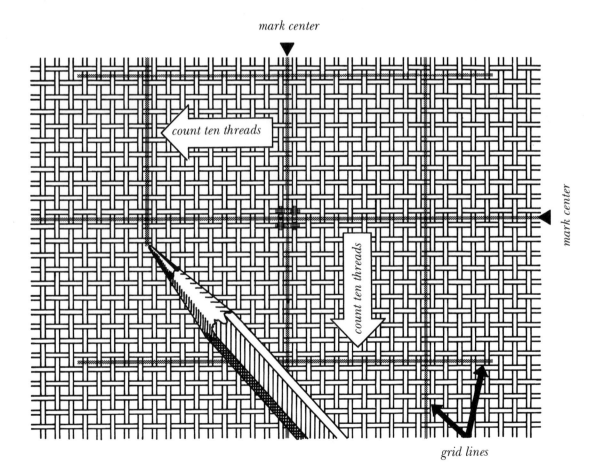

mark center

count ten threads

mark center

count ten threads

grid lines

To make a grid on your canvas, you must first find the center of the canvas by using a ruler and measuring from the top and from the side. Then, with a hard lead pencil (4H), extend these two center lines from side to side and from top to bottom, so that the entire canvas is divided into four equal parts. Grid lines are always drawn *between* two parallel canvas threads. You'll find that your pencil will glide easily between these threads. You can see that there are places for four stitches around the intersection at the center. With a pencil or with paint, make a mark on each of these canvas thread intersections; you will then be able to see at a glance where the center is. Now count ten canvas threads from the center toward the edge of the canvas, in any direction to begin with, and draw the first line of the grid. Count ten more canvas threads from this line and draw the next line. Continue counting groups of ten threads from the center lines toward the edges of the canvas until you have the same number and placement of grid lines on your canvas as there are accented lines on the graph in the book. The horizontal pencil lines will intersect with the vertical pencil lines to form little blocks of ten canvas threads by ten canvas threads, or groups of 100 intersections.

Because, as in each of the graphs in this book, the center dividing lines are *between* the canvas threads, not all of the graphs will have even numbers of spaces outside the last accented line. Mark the top of your canvas; then make sure you have the correct number of grid lines drawn on the canvas. Now count from the graph the number of rows beyond the outermost accented lines, and draw the outline around the grid on your canvas. If you make a mistake, you can erase with a kneaded eraser. Double check your grid count, because if any grid line is misplaced you'll have a terrible time trying to get the stitch count to work.

Caution: If your design has any large areas of white or pale shades of wool, even hard lead pencil might be picked up by the yarn as it's drawn past the mark, causing the lines to show and probably ruining your piece. To prevent this from happening, you should

use acrylic paint and a brush to make the grid lines, or should cover the pencil lines with the paint once they are drawn correctly. Some people like to use yellow paint as it comes from the tube, but it is difficult to see at night under incandescent lighting. I think the best thing to do is to make a light gray mixture, starting with a small amount of white paint and adding minute bits of black, mixing and thinning with water, until you can just see a dab of it on the canvas when it has dried. The ideal consistency for the mixture is about that of heavy cream. Painting on needlepoint canvas is easy if you get yourself a good-quality sable watercolor brush. (I recommend Winsor & Newton, Ltd., Series 7, size #1. If your art supplier doesn't have it, ask him to suggest something comparable.)

Many people like the convenience of the felt-tip marker, but you are definitely taking a chance if you don't test it first. Because the degree of indelibility of various inks on different grades of canvas varies considerably, you must test even the recommended brand, Sharpie, on the canvas you are going to use. *To test:* mark a scrap or a corner of your canvas with the marker. When the ink is dry scrub it hard with a wet cloth; actually *try* to get the ink off. If *any* comes off, don't use the marker. Try another method of drawing the grid.

Make the same test even if you use the acrylic paint method; wait until the paint is dry on the canvas. It may seem overcautious, but the truth is that if anything on your canvas runs when it becomes wet, the piece is likely to be ruined.

The Stitches: How to Do Them

Fig. 1

The fundamental needlepoint stitch is a slanted bit of wool covering a pair (or two pairs, in the case of penelope canvas) of intersecting canvas threads. The wool always comes up from the lower left-hand hole, diagonally over the crossed threads, and into the next hole up and to the right. (See Fig. 1.) There are three styles of stitching that result in this basic stitch, each producing a different effect on the wrong side of the canvas. They are the half-cross, the continental, and the basketweave. We'll not be concerned with the half-cross stitch in this book for two reasons: (1) it does not mix suitably with other stitches on mono, and (2) it does not adequately cover the wrong side of the canvas. The stitches required for working the pieces in this book are basketweave and continental. The basketweave is used for backgrounds and design areas, except where continental is necessary for outlining. Basketweave is the stitch used most often because it ensures greater stability for the shape of the finished canvas. As you see in Fig. 2, continental draws the canvas threads together with equal pressure on both front and back, making it very difficult for you to keep the completed embroidery from assuming the shape of a parallelogram. Basketweave distributes the tension over the back of the canvas, offsetting to some degree the pull on the front (Fig. 3).

If you are a beginner and want to get a better understanding of how to do these stitches, it's best to have a scrap of canvas and a threaded needle to work with as you read through the directions in the next three sections of this chapter.

Fig. 2 *Continental*

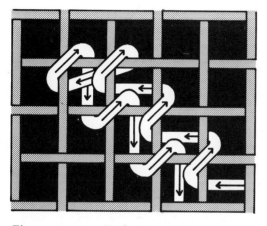

Fig. 3 *Basketweave*

BASKETWEAVE

The canvas is held stationary; that is, it is never turned upside down, as it is for the continental stitch. Always begin at the top right-hand edge of the area to be worked.

Bring your threaded needle from the wrong side of the canvas to the front through the hole at Point #1. Pass it to the diagonal upper right into the hole at Point #2, bring the needle back up through the canvas at Point #3, and pass it, again to the diagonal upper right, into the hole at Point #4, in the same movement pass it straight under two canvas threads vertically to Point #5. Pass the needle to the diagonal upper right and into the hole at Point #6. As you follow this pat-

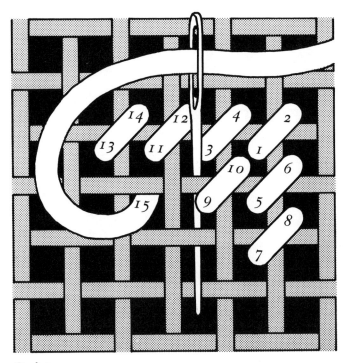

Basketweave

tern, notice that the needle is in a horizontal position as you work a row going up, and in a vertical position as you work back down.

Make sure that when you stop work, you are in the middle of a row, with your needle in position for the next stitch. This is especially important when you're working on backgrounds and other large areas of a single color. The objective is to keep unbroken the woven pattern of the basketweave stitch on the wrong side of the canvas. If you finish a period of work at the end of a row without leaving yourself some indication of your direction, you risk causing noticeable ridges that will not block out.

CONTINENTAL

Always begin at the top right-hand side of the area to be covered.

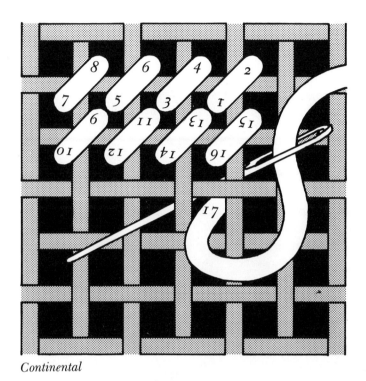

Continental

Bring the threaded needle from the wrong side of the canvas up through the hole at Point #1 of the diagram. Point it to the diagonal upper right, into the hole at Point #2, and in the same motion pass it across two vertical canvas threads at the back and up through hole #3. This is the beginning of the second stitch. Continue stitching in this pattern until the last stitch of the row. Complete this stitch, drawing the needle to the back of the canvas, and then turn the canvas completely upside down so that you will again be working from right to left. Pass the needle up through the hole at Point #9 and proceed as before.

OUTLINES: MIXING THE TWO STITCHES

There are eight potential directions an outline can follow, and continental is used for all but two of them:

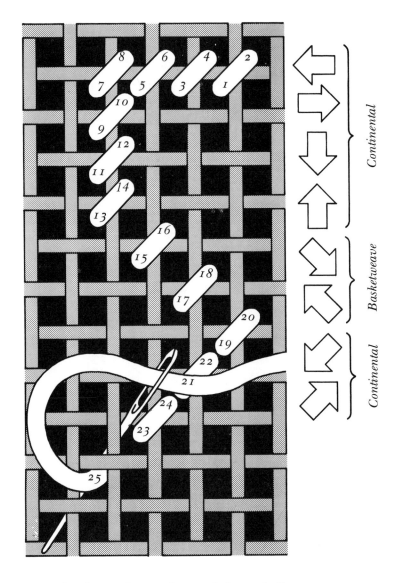

1. A horizontal row from right to left.
2. A horizontal row from left to right. The canvas must be turned upside down, so you'll actually be working again from right to left.
3. A vertical row from the top to the bottom.
4. A vertical row from the bottom to the top. Again, the canvas is turned upside down, so you'll be working from the top to the bottom.
5. A diagonal row from the upper right to the bottom left. This version of the continental stitch is only slightly different from the horizontal and

vertical, because the position of the needle follows the diagonal of the row, always from the upper right-hand side to the lower left.

6. A diagonal row from the bottom left to the upper right. Once again the canvas is turned, so you'll be working from top to bottom.

Use basketweave, without turning the canvas, for:

7. A diagonal row of stitches running from the upper left to the bottom right.

8. A diagonal row of stitches running from the bottom right to the upper left.

Everything else, background and the filling-in of small areas of color throughout the design, should be done in basketweave.

COMMON PROBLEMS: SOME SOLUTIONS

Occasionally, in the course of working a piece, you will find it necessary to put a single stitch in an area by itself, though you'll probably find this true more often toward the end of the work, when you fill in skipped stitches. Feel the thickness of the wool padding on the wrong side of the canvas and run the needle through any of the surrounding area to the immediate lower left-hand side of the space for a length of four stitches, make the stitch, and then run the needle through the thinnest part of the area to the immediate upper right-hand side. Try not to have the buried ends of the wool form a straight line with the stitch, as the stitch could be pulled out easily. Careful attention to this kind of detail, even though it is time-consuming, pays off in a smooth, professional-looking canvas.

Once you've mastered the stitches and understand how they're used, you can employ some other techniques to ensure the smooth surface and neat reverse side of a successful canvas.

One of the causes of a lumpy surface in needlepoint is "runners" on the back of the canvas. These are the lengths of wool that the unwary might use to string together the first groups of stitches made on the can-

cut away

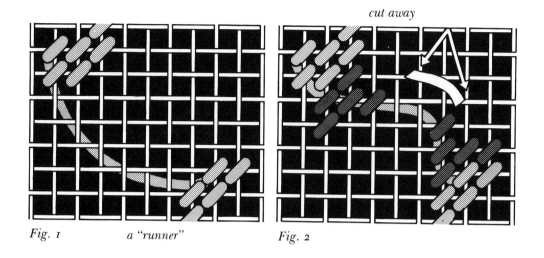

Fig. 1 a "runner" *Fig. 2*

vas. Almost imperceptibly, these loops of wool draw the empty canvas in, distorting it just enough to make it impossible for you to flatten out the canvas during the blocking. If you are going to have more than eight stitches of one color, hold a short length of wool at the back of the canvas and catch it in the first four or five stitches. Finish putting in the rest of the group, and anchor the tail end of the wool by running it through the last four or five stitches of the group. Trim any wisps of free wool. If you have fewer than eight stitches in a group, with no completed stitches nearby in which to anchor tails, you will have to run, to the next spot, a loose thread, or runner, from the previous group of stitches of that color (Fig. 1). Keep this thread slack, and as soon as possible, catch it in four or five stitches of the color that belongs next to the group it comes from (Fig. 2). Anchor the other end in the same way and clip away the entire center of the thread, as shown in Fig. 2.

These runners must be avoided, as well, in the rest of the work. Always anchor the tail ends of the wool in the stitches that have accumulated the least bulk, and trim the excess immediately. Never allow a loop of wool to remain on the reverse side of the canvas. If the next stitches you wish to work are closer than eight stitches away, and if the direct path between them hasn't already become too thick with wool, you can run

the wool *under* the backs of the stitches in its path. Please do not leave them to flap in the breeze. However, if this path is too congested, run the tail under the backs of stitches in a direction with thinner padding, cut it, and begin the next group as usual. Remember, not a single filament of wool that isn't doing its share of the work should remain on the canvas.

Another major problem is that of tension. If you pull too hard on the yarn as you stitch, the finished canvas will be misshapen, sometimes irrevocably. Never do needlepoint when you're tense or angry. If you must, place yourself mentally in a hammock in a balmy glade and work this way: halfway through the motion of drawing the yarn away from the canvas, drop the needle, pick up the thread in your fingers, and gently complete the stitch without tugging. You can further alleviate the tension of the stitches on your canvas by using a frame to hold the canvas fixed in a rigid position. This can be accomplished with canvas stretchers that you can purchase from an art supply store. Sew, staple, or use thumbtacks to attach the canvas to the frame, stretching it taut. Although this method produces excellent results, it is cumbersome because you must stab the needle through from both sides of the canvas. An embroidery hoop is almost as effective, and is more convenient because it's smaller and you can move it around as you work.

Have you ever noticed that sometimes a strand of wool will glide effortlessly through the canvas, and at other times it seems to snag, twist, or curl, and you must battle to get it through? Believe it or not, there is a right and wrong way to each strand. You can learn to tell which is which by running your fingers lightly up and down the strand — one direction will feel slightly smoother than the other, and the thread should be in this direction when it heads into the canvas. It does take practice to learn . . .

Even though the thread is running in the right direction, it still has a tendency to twist. You can prevent its twisting by giving the needle a slight twirl after each

stitch. If the thread does get snarled, hold the canvas up, let the needle fall free, and the thread will unwind itself.

Remember that when you stop work you should be in the middle of a row, with the needle in position for the next stitch. This will prevent the occurrence of the unsightly ridges that form if two rows are worked in the same direction.

Wash your hands before working on your embroidery, especially if you're working with white or other light shades of yarn. I've found that during a long period of work my hands seem to manufacture soil of their own, and I wash them every so often. If you permit dirt to get into a piece while it's being worked, you'll find it difficult, or impossible, to wash the dirt out.

Never leave a knot anywhere on the canvas. If you like to begin with a knot, remember to cut it away.

Needlepoint wool, like fine knitting wool, is dyed in large batches, one color at a time. And as with anything done by hand, certain variable factors sometimes cause slight discrepancies in the cast of a shade from one dye-lot to another. The headache of matching these dye-lots can be avoided if you buy *more* than you think you need for backgrounds and any other large areas of one color. If you run out of a color from the busy design portion, matching the dye-lot isn't important because the surrounding colors distract the eye, making a different shade hard to spot. If you do need to match a color exactly, hold a piece of the original wool along the hank of new wool, with the strands running in the same direction. In bright sunlight you'll be able to detect any difference.

Everyone accidentally skips a stitch here and there, so when you've completed your canvas check it over carefully, a small section at a time. It helps to hold it up to a light; missed stitches will show as pinpoints of light. Use straight pins to mark any spaces you need to fill in. If you find very many, thread several needles with the missing colors; then you won't have to stop constantly to thread the same needle over and over.

The Graph: How to Work from It

A graph for needlepoint is a specialized kind of map, indicating the exact location for each stitch of a specified color in relation to every other stitch in the design. Each graph is divided by accented lines into blocks of 100 squares each. Your canvas is divided, by the grid lines you have drawn, into corresponding blocks of 100 stitches. You will be able, then, to find the spot you want by counting blocks until you reach the correct one. After that, you have to count only individual spaces within a block. This means you should never need to count more than ten spaces (or stitches) at a time.

Each square on the graph contains a symbol representing a color. There is a list for each design, showing the symbols, their numerical identification for the Paternayan chart, and a description of each color. A blank square is the same as a symbol; it is listed with the other symbols and usually represents the background color. Label clearly each hank of wool with its number and symbol before you begin work.

There is only one graph for each design, but it is presented in several different ways, to make the business of copying from it easier. (The one shown here is from "1825: The Emblem of Our Country," one of the designs in the book.) First, you see the whole graph reduced to fit on one page. This is too small for most of us to work from, but it will give you a chance to see how the portion you're working on fits into the whole pattern.

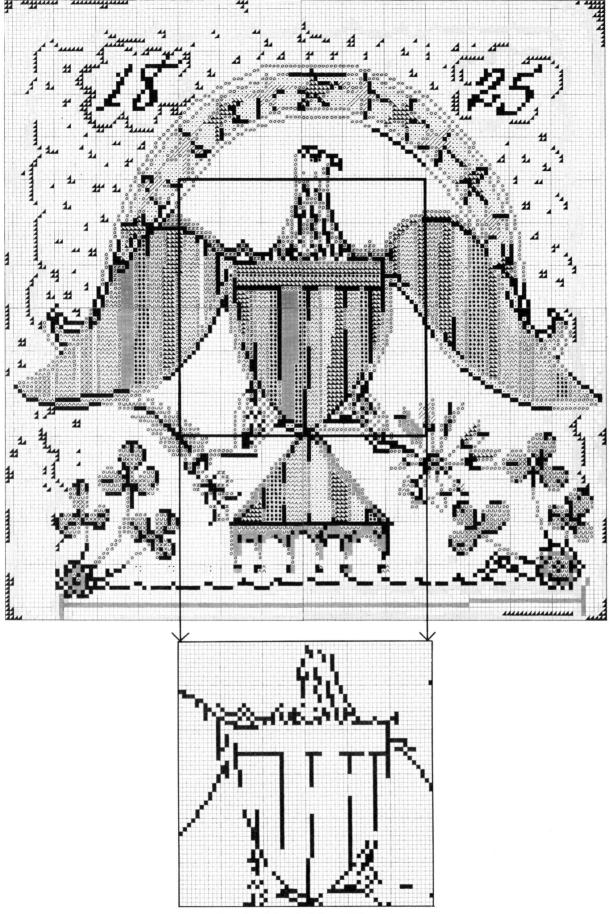

abbreviated detail of the middle section

The next graph is an abbreviated detail of the middle section, showing the placement of one or two colors only. These were chosen to be the first ones to be worked onto the canvas, and have been isolated to make the first counting easier. These will give you a good foundation to build on. *All* of the stitches of a particular color are included within the area of this graph, but there is usually more of that color to be found outside the area covered by this center graph.

The whole design is then divided along the center lines into sections, each section on a separate page, and made large enough for you to work from. They are arranged in sequence, beginning with the top half from left to right. Each section is assigned a letter that corresponds to one on a key, indicating its placement on the complete graph.

Everyone eventually will hit on the method that works best for him or her, but the following suggestions will help you get a good start. Use the center graph to get the first color or two onto the canvas. You might refer back to page 25 for advice on anchoring the ends of the yarn. When you're absolutely sure these stitches are correct, you will have a solid foundation against which to check the placement of the next stitches. Now you will have two ways to check the next stitches for accuracy: the counts from the closest grid lines to the stitch being worked, and those from the nearest stitches already established.

After you have worked and checked the first stitches, fill in the rest of the stitches in the blocks closest to the center, working in a pattern that fans out toward the edges of the canvas. You might like to use several needles threaded with the colors needed in the section you're working. Sometimes it's better to work a part of the design that is a complete unit in itself. For instance, a piece of fruit might be easier to do completely, without regard to the methodical outward progression just described. You shouldn't hesitate to proceed in whatever order seems the best for you.

Sometimes graphs are easier to follow if they are enlarged. If you wish, take this book to a shop that

makes photocopies and enlargements, and get a blown-up copy of your graph. It will be much more convenient to carry than the book, if you don't always work at home. If you find it difficult to distinguish between certain sets of symbols on the graph, you can make them even clearer by coloring one set (or several of them) with light-colored pencils or markers. Another effective trick, if you like to work one block at a time, is to cut out and discard a 1-inch square from a piece of paper or lightweight cardboard, and fasten the remaining paper or cardboard over the graph with masking tape, leaving exposed the block you want to copy. Apply only light pressure to the tape; it will be easy to lift and reposition the cutout over the other blocks.

In order to get the greatest pleasure and the best results from working these designs, work slowly and carefully. Check the position of each new color frequently, making sure that it matches the symbol shown on the graph and that it is in the correct place in relation to the other stitches on the canvas. I've found many mistakes by rechecking the stitches adjacent to the ones I've just put in.

Check the graph — how many stitches from the nearest accented line to this stitch? Check the canvas — what colors and how many of each between this stitch and the grid line? If everything matches, move on to the next stitch.

Try to arrange it so that when you're in an ambitious mood you do parts that require counting and concentration, and when you are more relaxed you can work on a simpler part, like a background. It's a good idea to have a selection of several pieces of needlepoint in progress, to fit every mood.

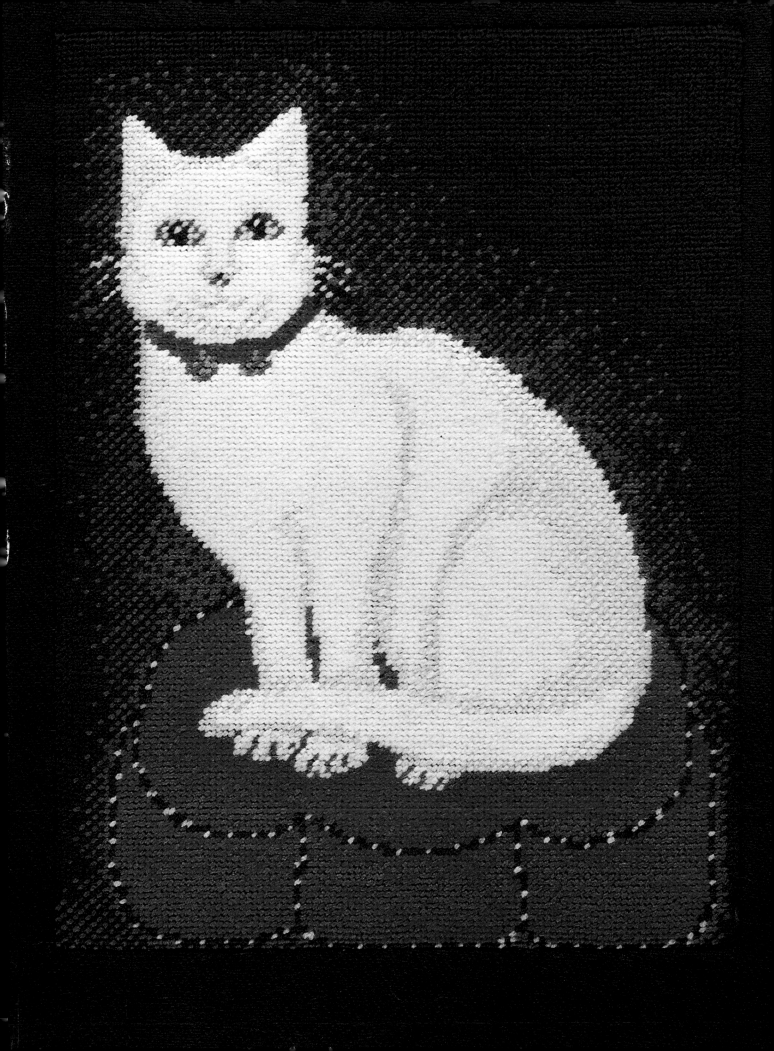

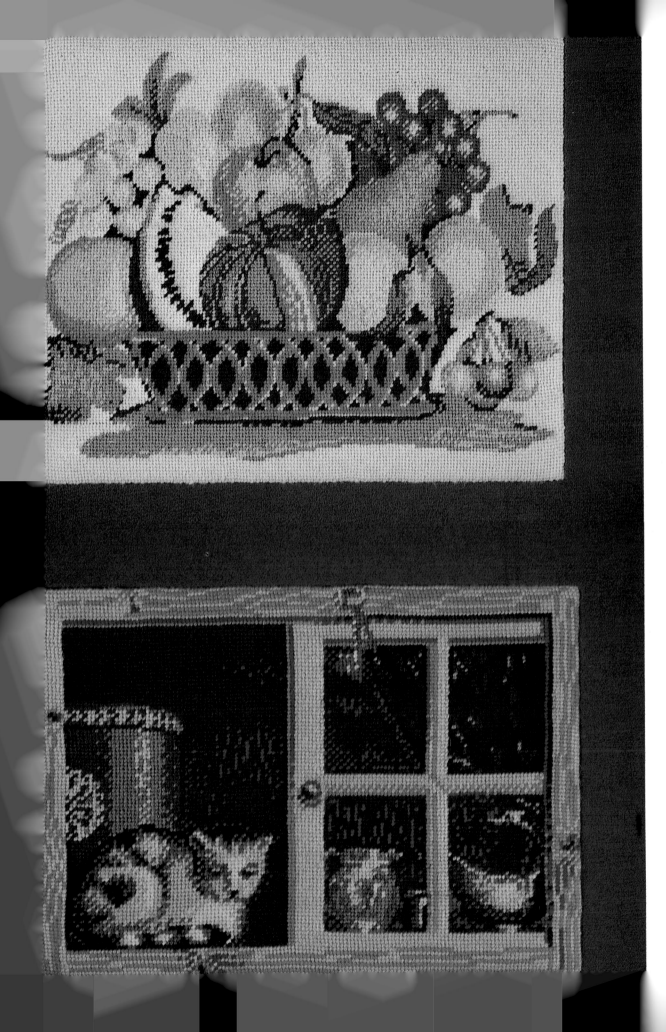

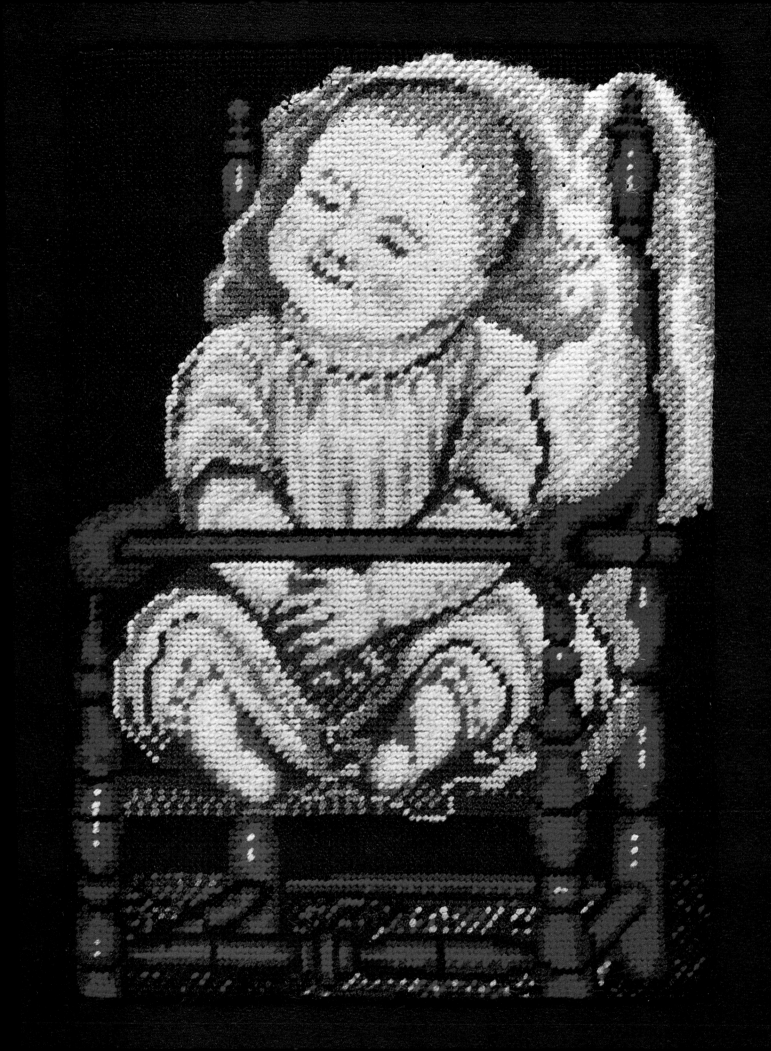

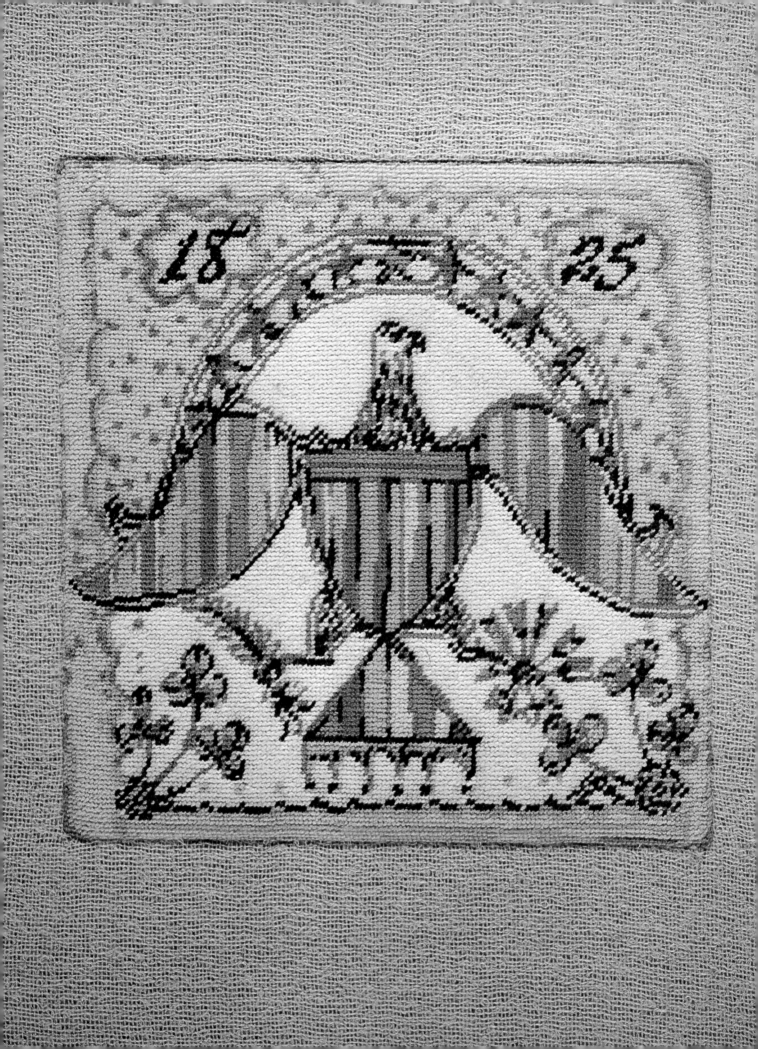

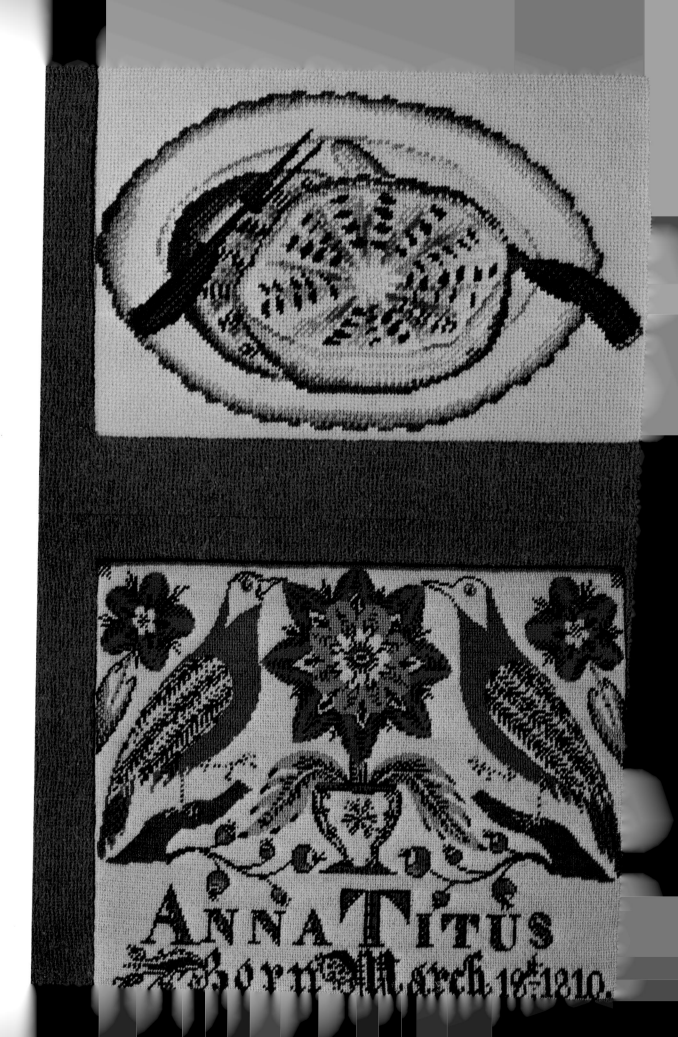

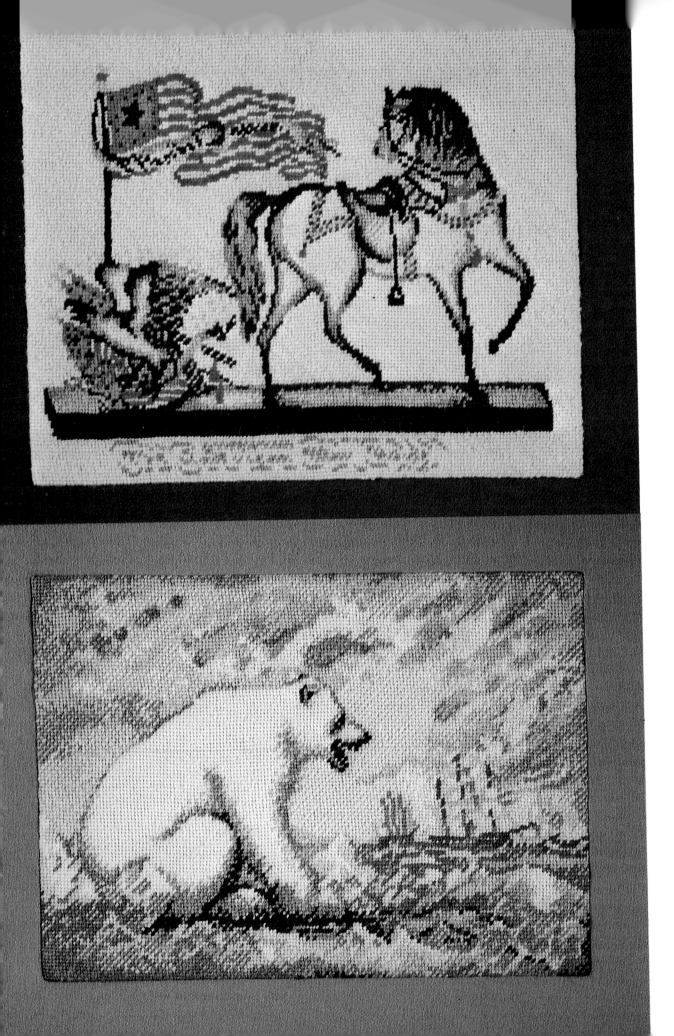

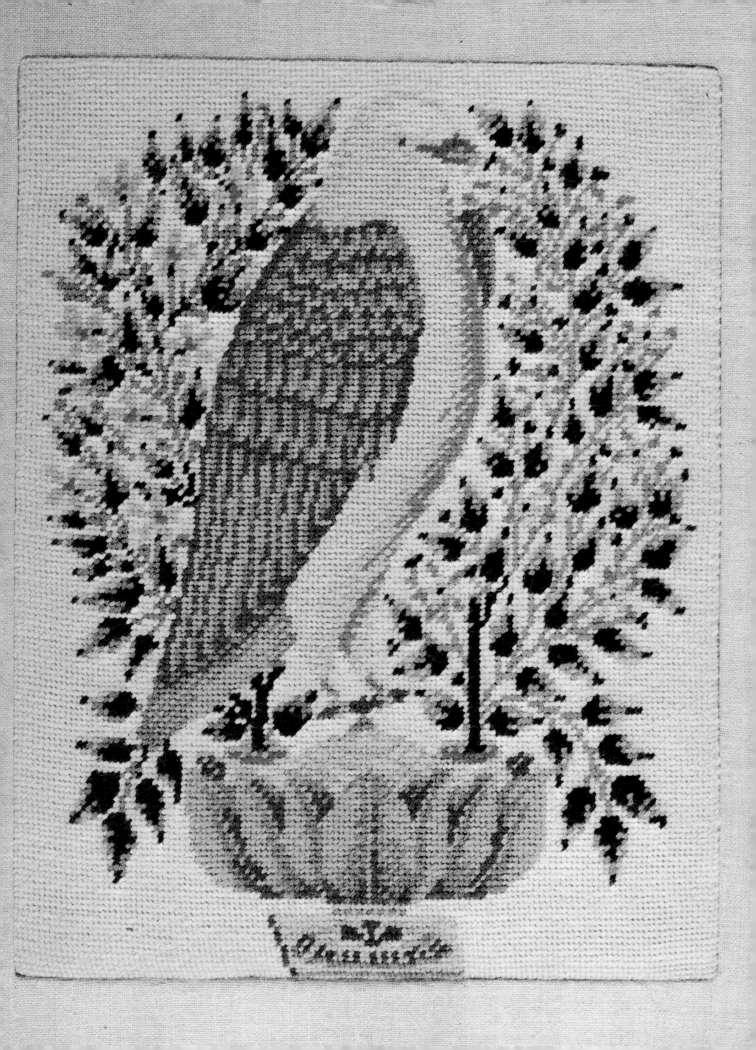

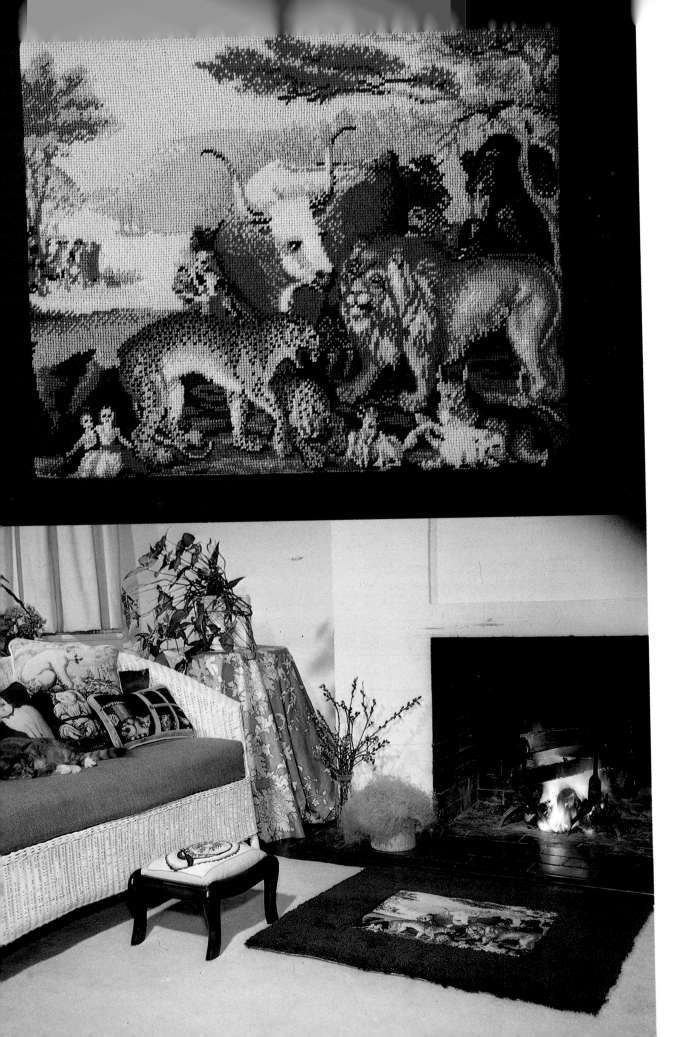

Watermelon in Blue-Bordered Dish

This is one of my personal favorites, a perfectly balanced composition of watermelon slices, a fork, and a knife on a plate with a blue, scalloped border. It was painted by an unknown artist around 1820–1840. The artist apparently cut his own stencils rather than using ones from a prepared theorem, and then applied the nearly dry watercolors to paper with a bit of velvet or other cloth instead of a brush. The original painting is 9½ inches by 14⅞ inches and is from the Abby Aldrich Rockefeller Folk Art Collection, in Williamsburg, Virginia.

Notice in the color plate that the sort of "bird's-eye" perspective of the painting was emphasized by the use of needlepoint to upholster a small footstool, making it seem almost as if the dish had been set there.

The needlepoint sample was worked by the author.

Thread Count: 153 x 100

Canvas Gauge	Approximate Size
#18	8⅝ inches x 5½ inches
#14	10¾ inches x 7⅛ inches
#10	15 inches x 9½ inches
# 5	30¼ inches x 20 inches

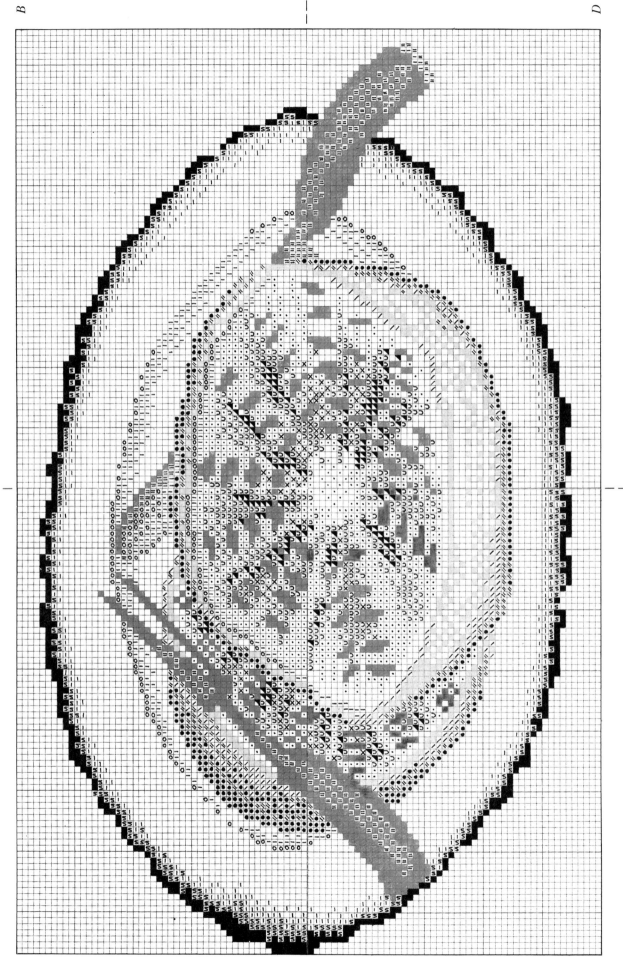

Light blue #382	—	\\ #530 Medium green	
Medium blue #381	∽	// #528 Dark green	
Darkest blue #311	■	● #340 Darkest green	
Light gray #168			• #870 Pale pink
Medium gray #164	O	∪ #860 Medium pink	
Dark gray #162	‖	◣ #232 Dark pink	
Darkest gray #105	▨	✕ #988 Orange	
Light green #537	▨	Blank #005 White	

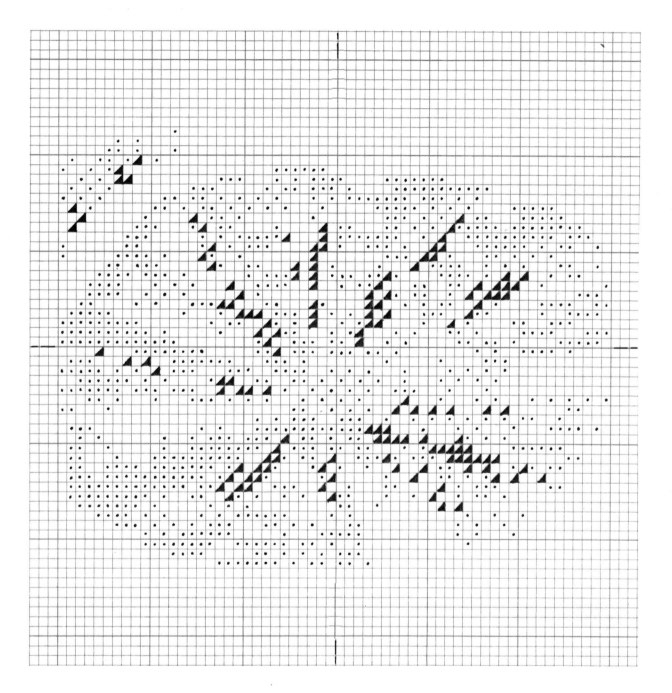

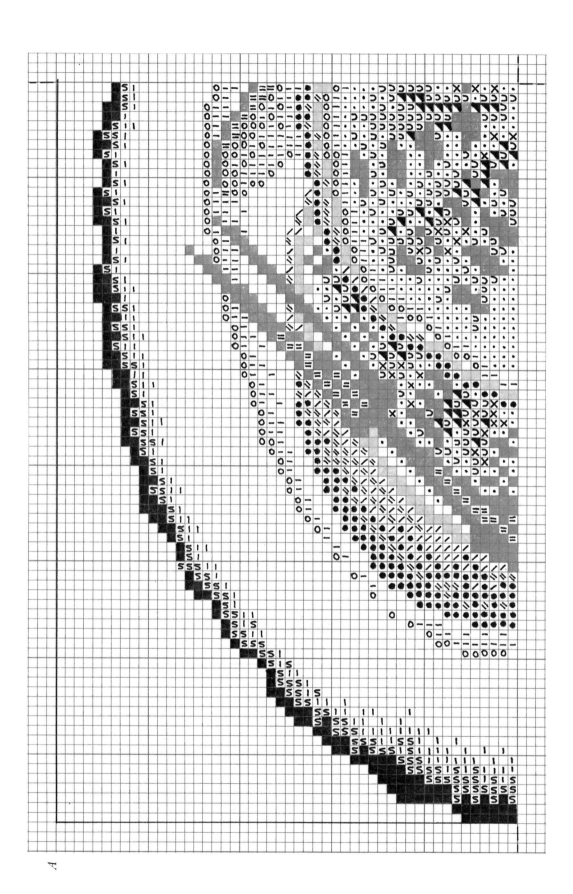

A

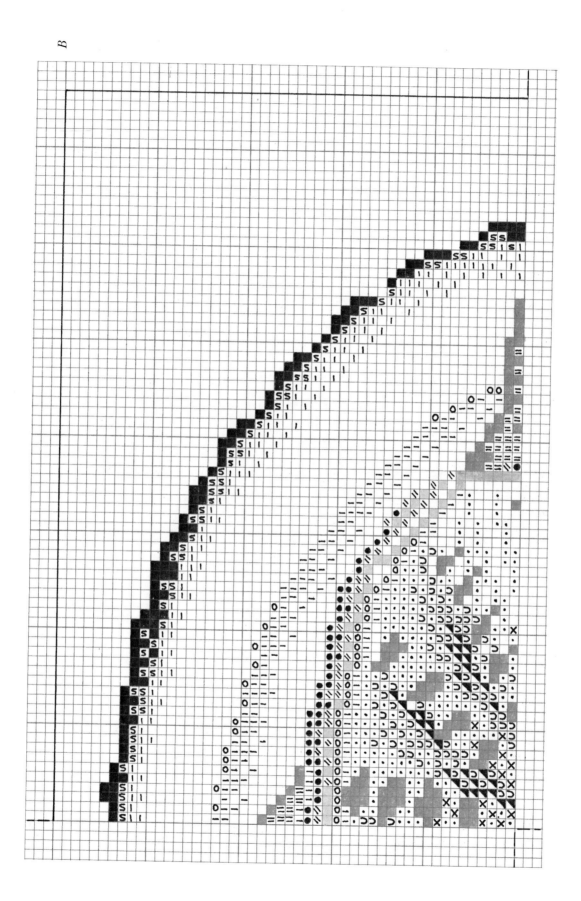

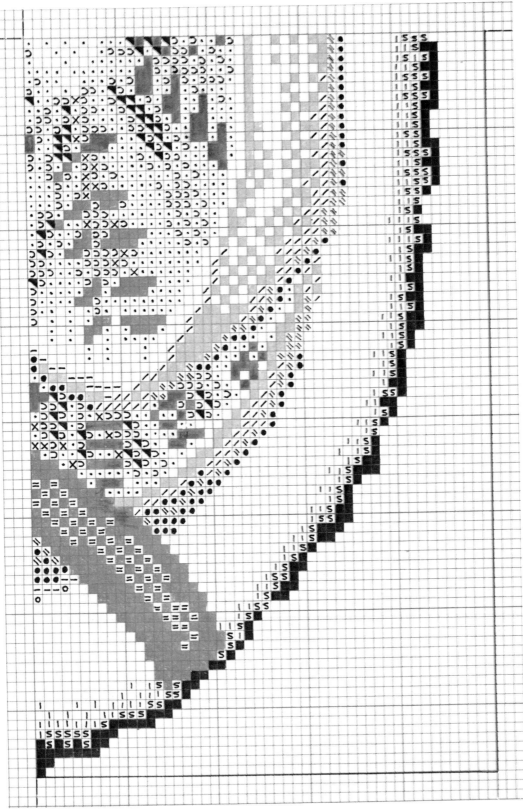

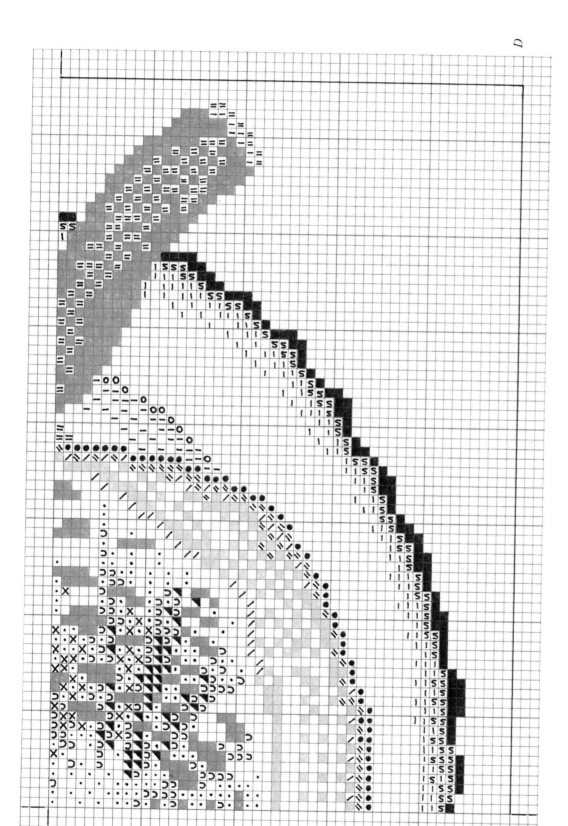

"1825": The Emblem of Our Country

This patriotic expression is a "fancy piece," painted by some schoolgirl or housewife to brighten the interior of her home, and was executed with watercolor and ink on paper in, not surprisingly, 1825. The original painting was 8 inches by 7¾ inches, and is from the collection of Peter H. Tillou.

As you can see in the color plate, this piece has a slightly darker beige background outside the scalloped border at the lower part of the picture and above the banner over the eagle's head. A lighter beige is used from the banner to the eagle's shoulders and below his wings to the border. In Fig. 1 the shaded area indicates the placement of the darker beige. If you're wondering why this painting has pink stripes, remember that watercolors often fade over the years, and these stripes were probably once red.

The needlepoint sample was worked by Betty McDonnell.

Fig. 1

Thread Count: 145 x 145

Canvas Gauge	Approximate Size
#18	7⅞ inches x 8¼ inches
#14	10¼ inches x 10½ inches
#10	13¾ inches x 14¼ inches
# 5	29 inches x 28¾ inches

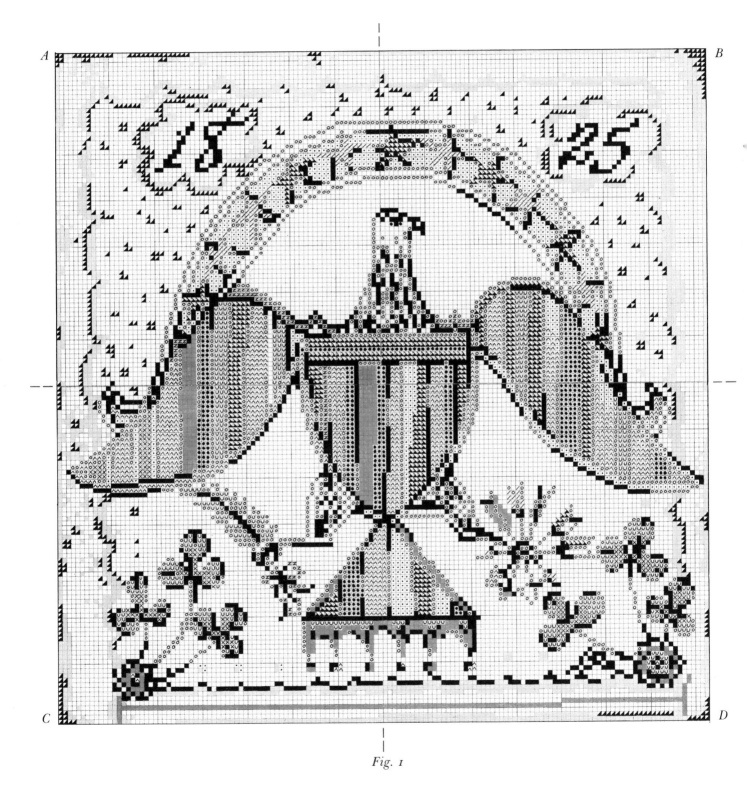

Fig. 1

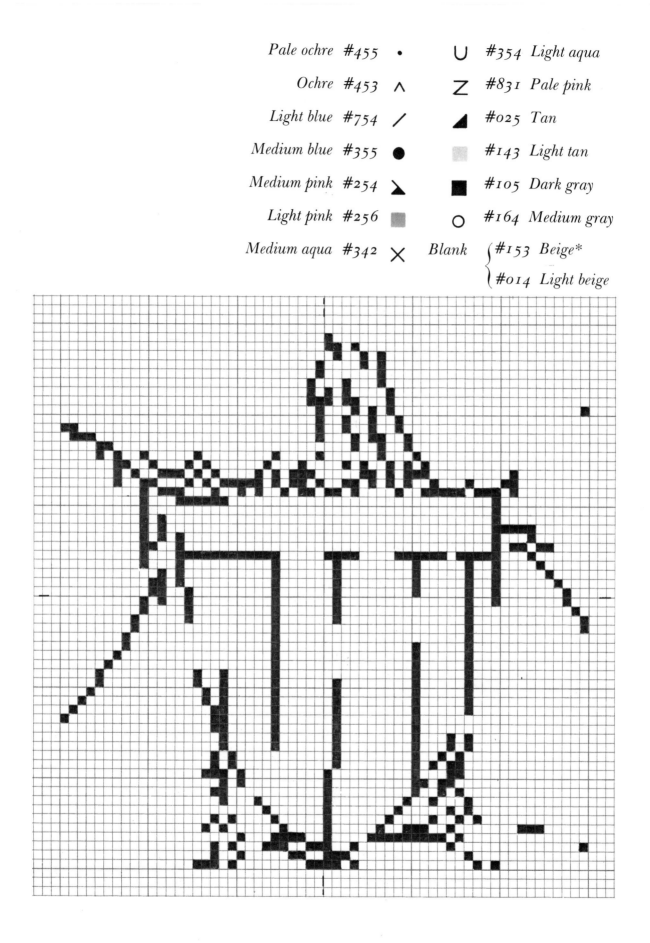

*See Fig. 1 for the placement of the two background colors.

A

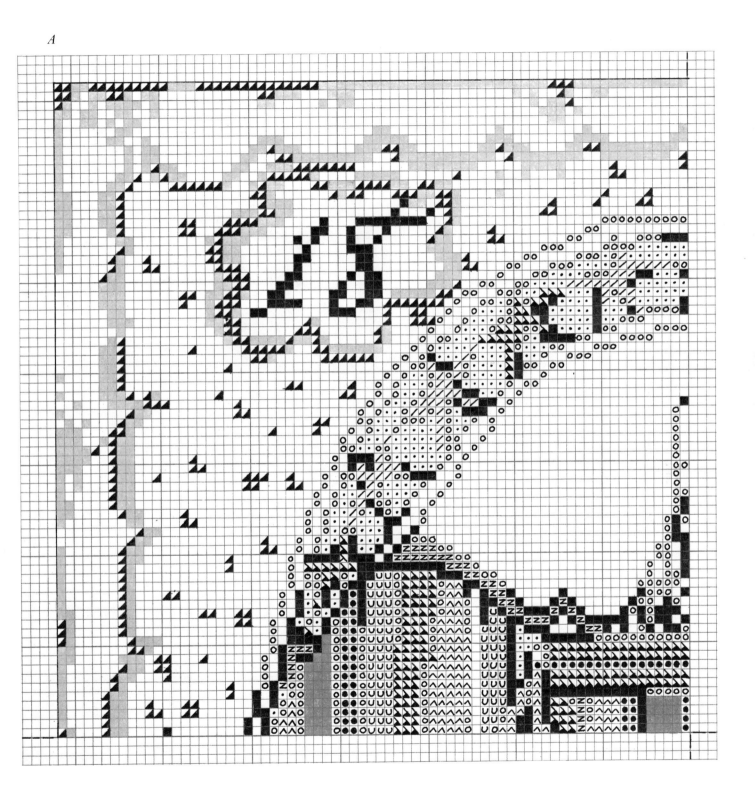

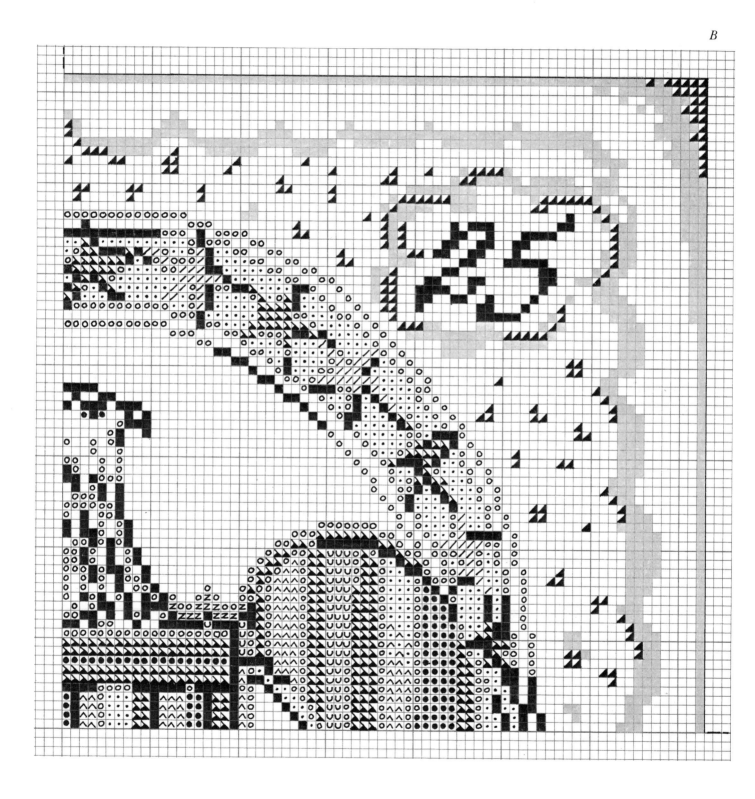

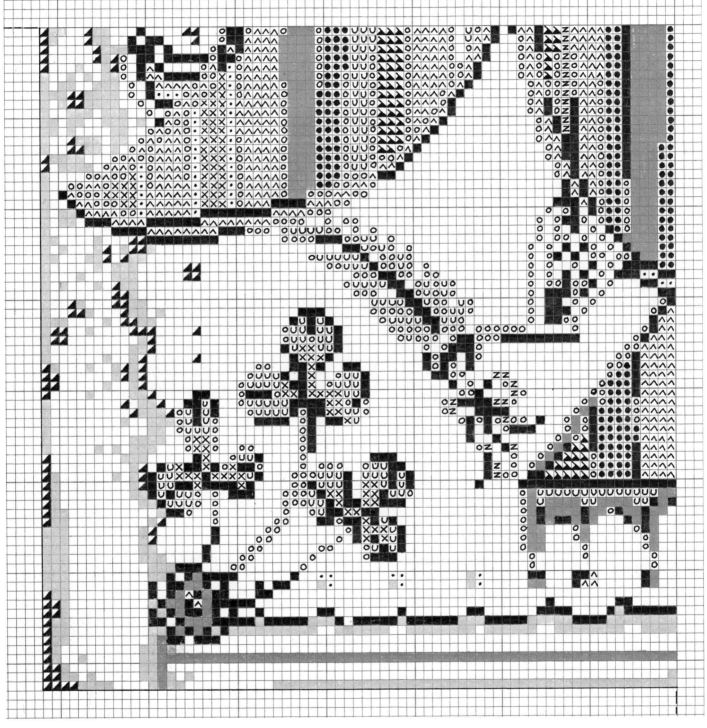

C

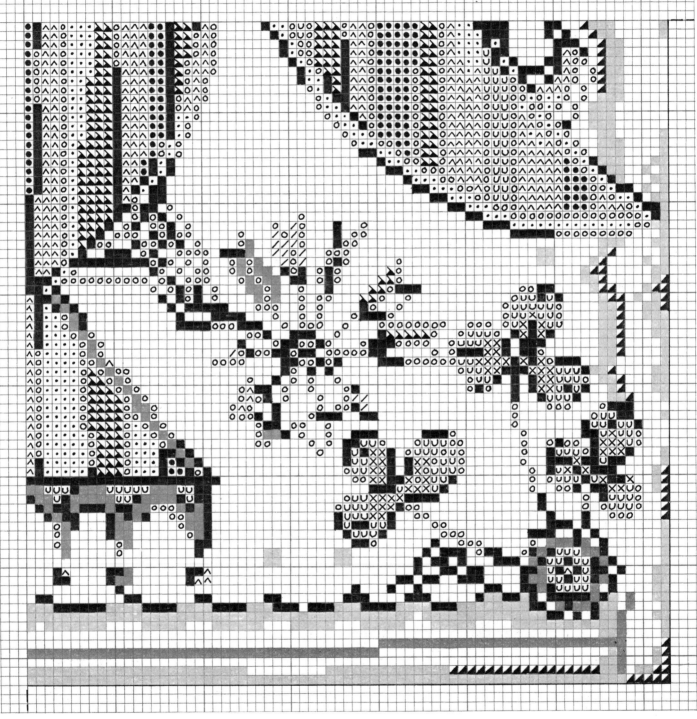

D

Tinkle, a Cat

We know that the cat, called "Tinkle," was two years old in 1883, when this portrait was made, but, in keeping with tradition, the artist remains unknown. The painting was executed in oil on a piece of academy board, 23¾ inches by 18 inches, and belongs to the Shelburne Museum, in Vermont.

The needlepoint sample was worked by Alberta Saletan.

Thread Count: 115 x 156

Canvas Gauge	Approximate Size
#18	6¼ inches x 8½ inches
#14	8⅛ inches x 11⅛ inches
#10	11¼ inches x 14¾ inches
#5	22¾ inches x 31¼ inches

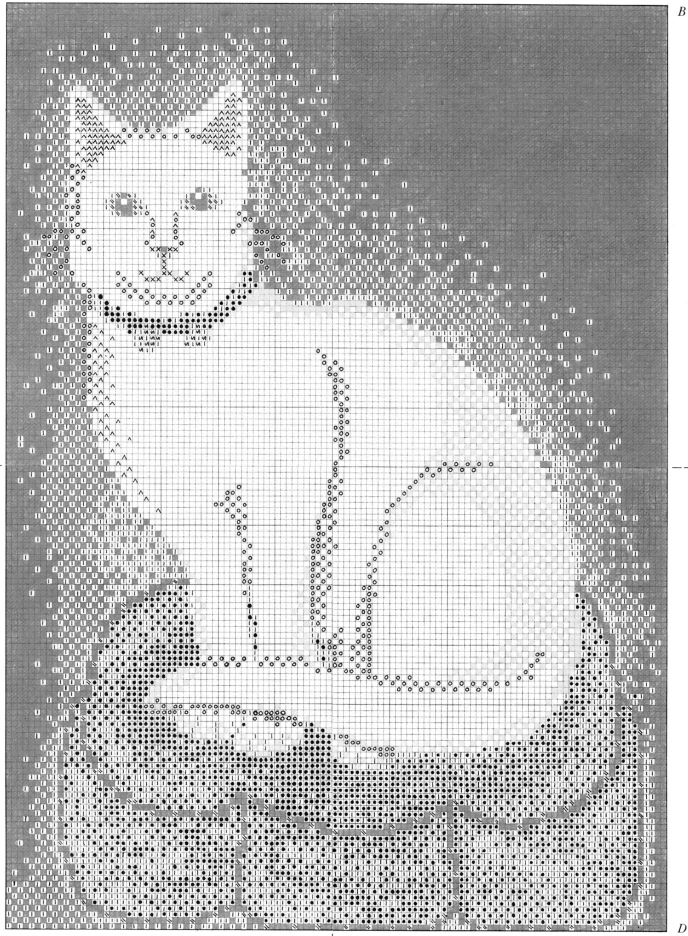

Pale yellow #455 ▦ ✕ #487 Pink

Medium yellow #497 \\ ● #R80 Red

Dark yellow #445 S | #283 Dusty pink

Pale gray #168 O ▦ #201 Dark red

Pale pink #014 ∧ Blank #005 White

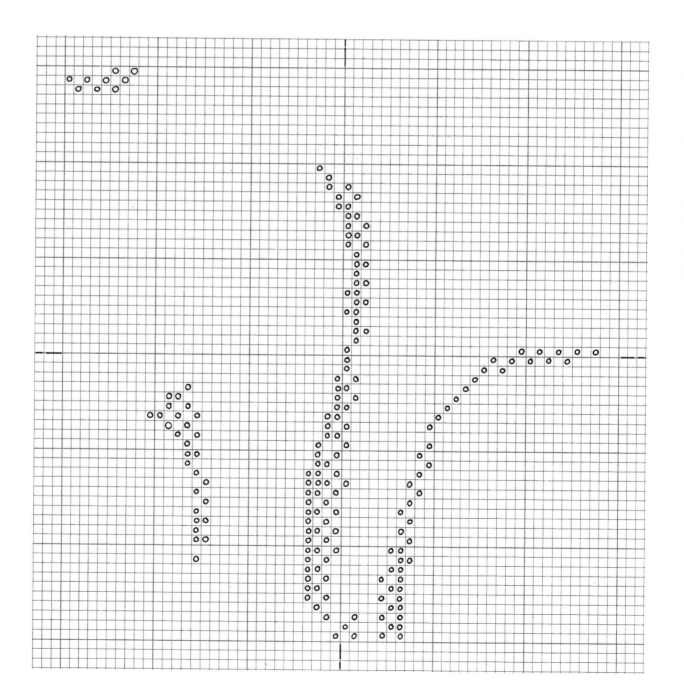

D

Baby in a Red Chair

Sometime between 1800 and 1825, an unknown portrait artist captured the sentimental charm of a baby asleep in its chair. This informal portrait is a good example of the way the folk artist served the needs of his countrymen by providing an intimate record of a warm moment in the life of a family, which in later years would be taken with a camera. It was painted with oils on a 22-by-15¼-inch canvas, and is from the Abby Aldrich Rockefeller Folk Art Collection, in Williamsburg, Virginia.

The needlepoint sample was worked by Frances Tenenbaum.

Thread Count: 146 x 100

Canvas Gauge	Approximate Size
#18	8 inches x 5⅝ inches
#14	10⅜ inches x 7⅛ inches
#10	13¾ inches x 9⅞ inches
#5	29½ inches x 19¾ inches

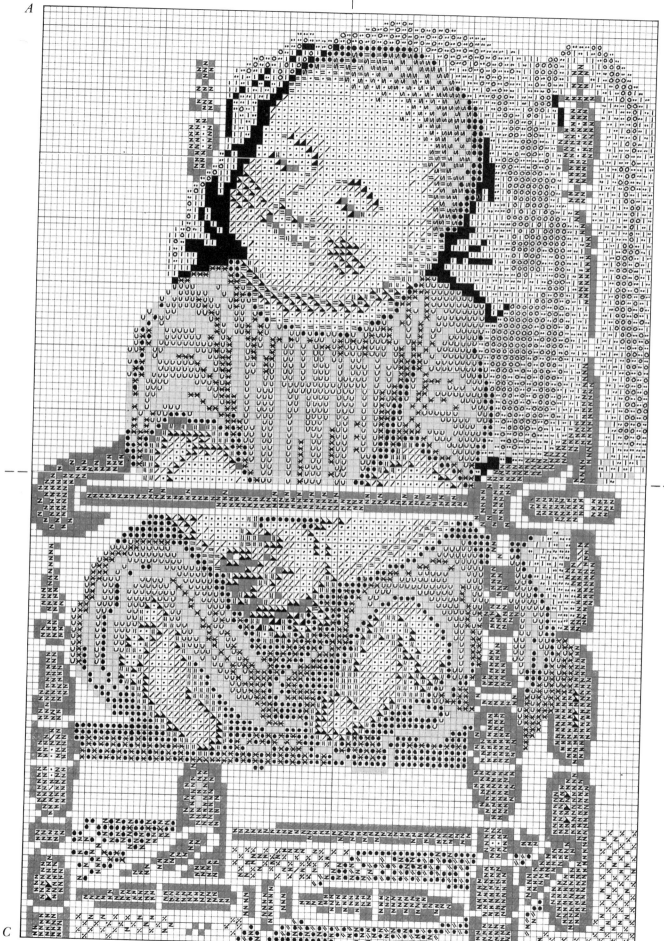

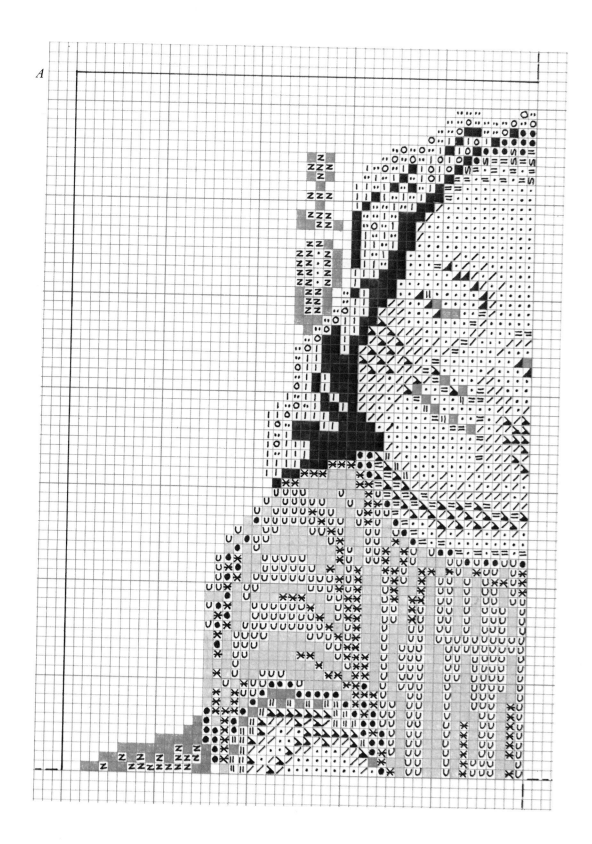

B

D

Birth Certificate of Anna Titus

The Germans who settled in Pennsylvania brought with them an unusual style of writing and decorating documents. The script was elaborate, and the decorative elements, such as hearts, angels, birds, and other animals, were usually arranged symmetrically. This piece could be made into a birth or marriage certificate for someone you know. Following the graph, you'll find several alphabets that were designed to go with this piece. You may use any wording you want. Just figure out how you want the lines to read, then copy them on to graph paper, one line at a time. Cut the lines apart, fold each to find the center, then tape them back together with the centers aligned, and your own graph is ready for you to use.

This fraktur was drawn by an unknown artist in 1810, with pen and watercolor. The original is 7 inches by 9 inches, and is from the Baltimore Museum of Art, gift of Edgar William and Bernice Chrysler Garbisch.

The needlepoint sample was worked by Betty McDonnell.

Thread Count: 173 x 213

Canvas Gauge	Approximate Size
#18	9½ inches x 12 inches
#14	12¼ inches x 15 inches
#10	16⅜ inches x 21 inches
#5	34⅝ inches x 42 inches

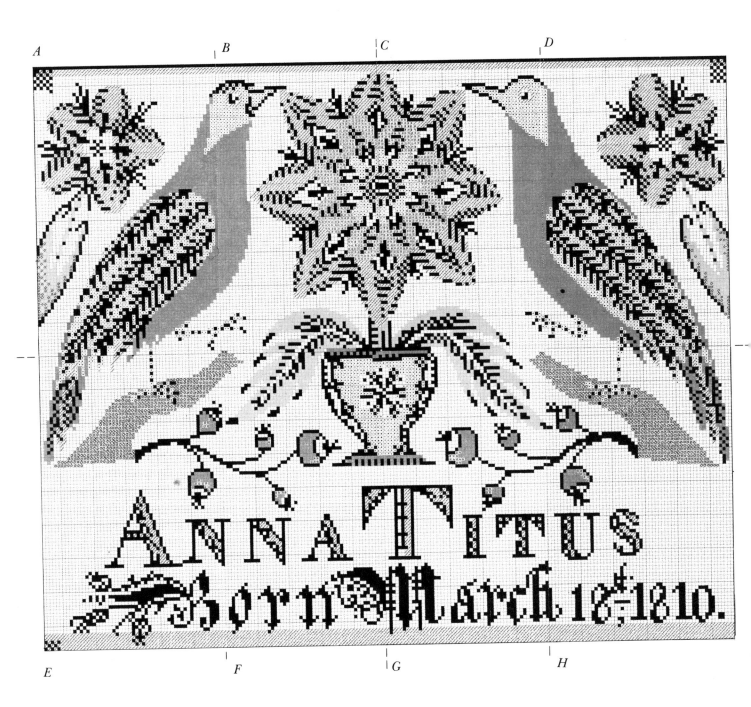

Yellow	*#437*	•	○	*#507*	*Dark green*
Red	*#242*	/		*#526*	*Green*
Blue	*#385*	‖	■	*#105*	*Black*
Dark blue	*#334*	▨	*Blank*	*#015*	*Pale ochre*

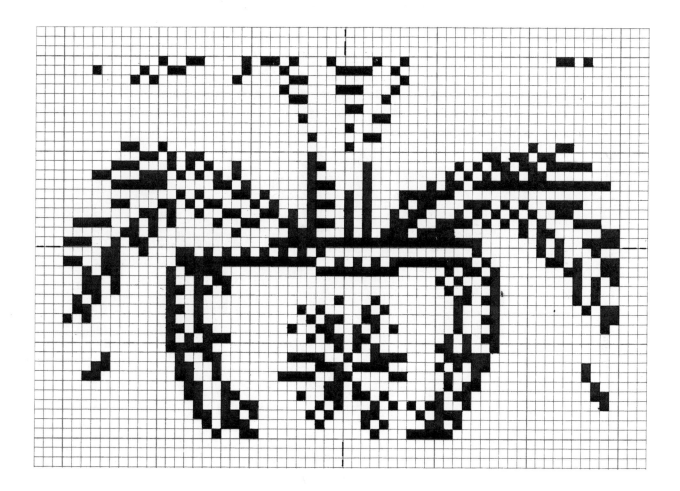

A

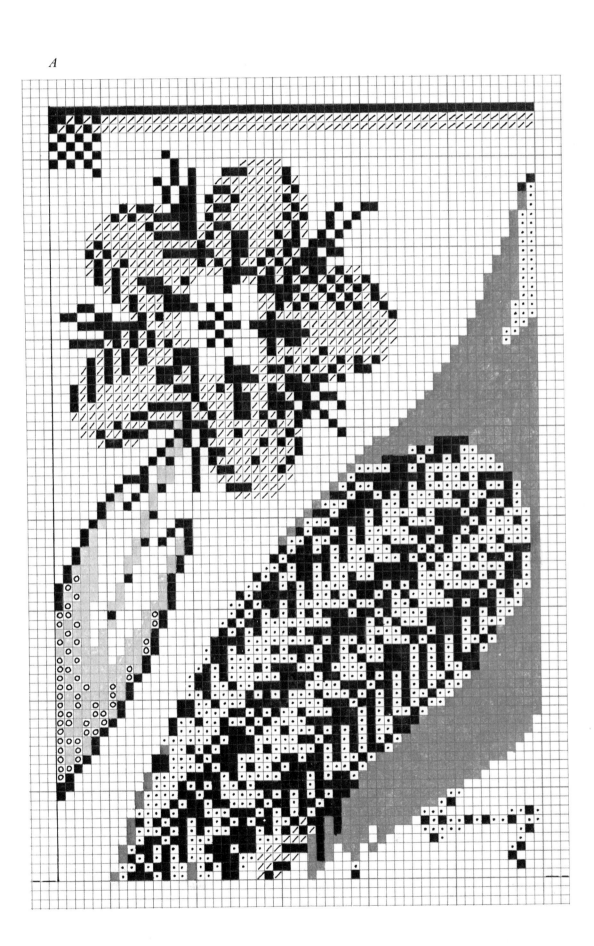

B

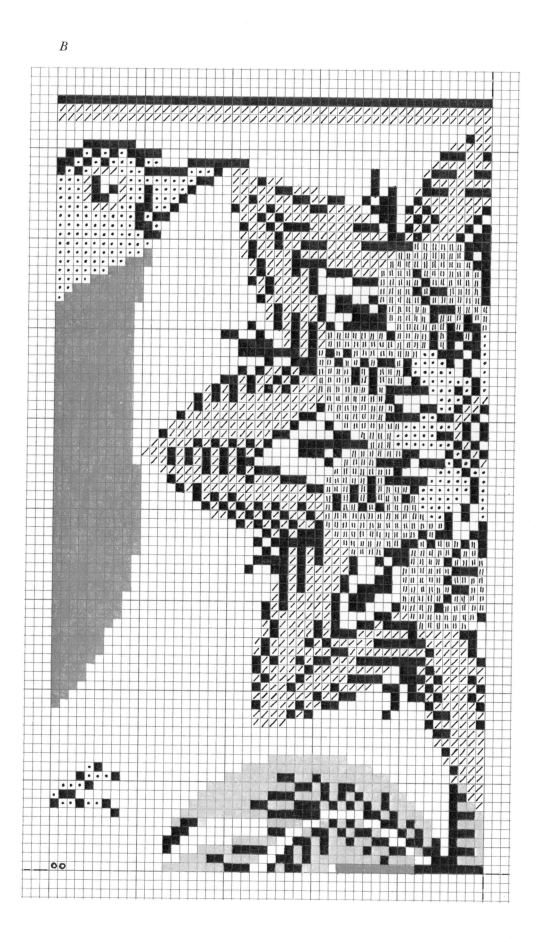

C

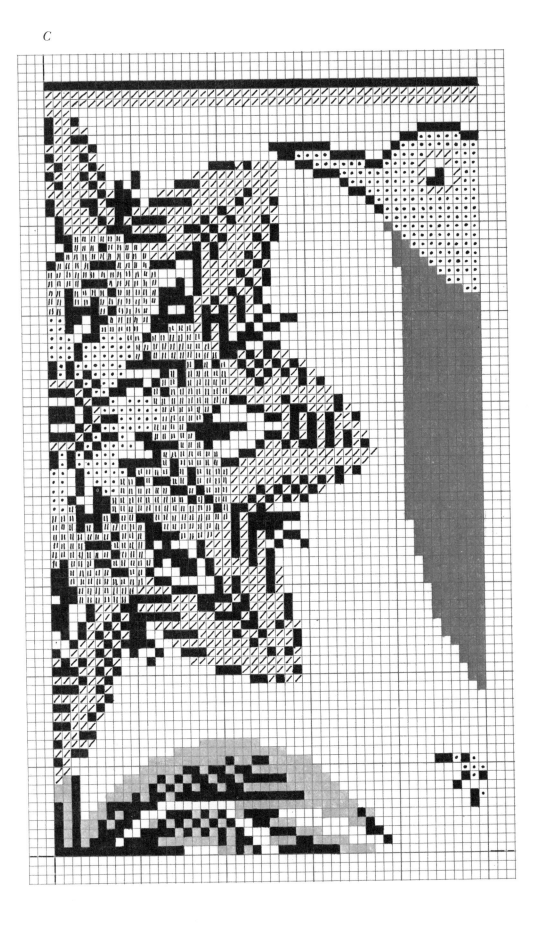

D

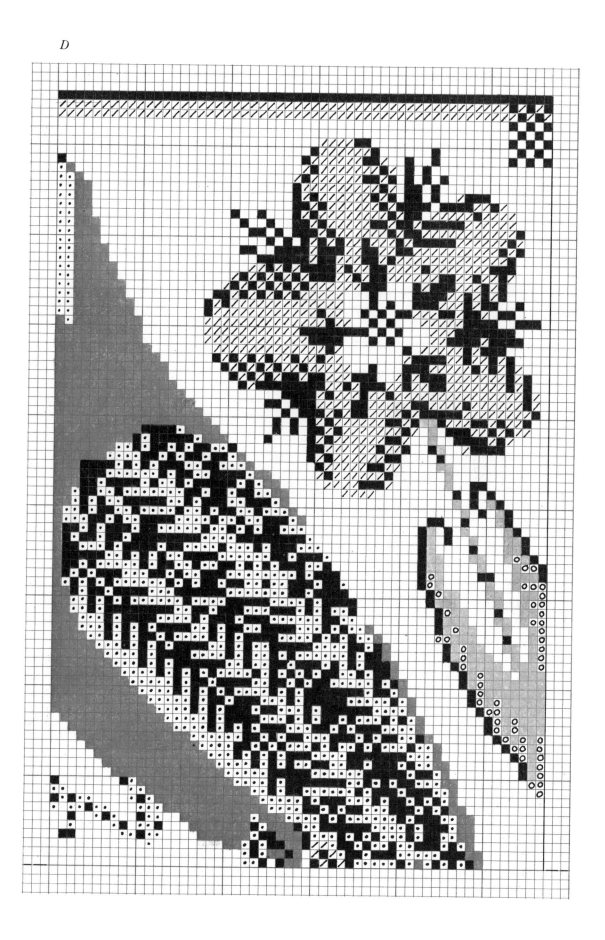

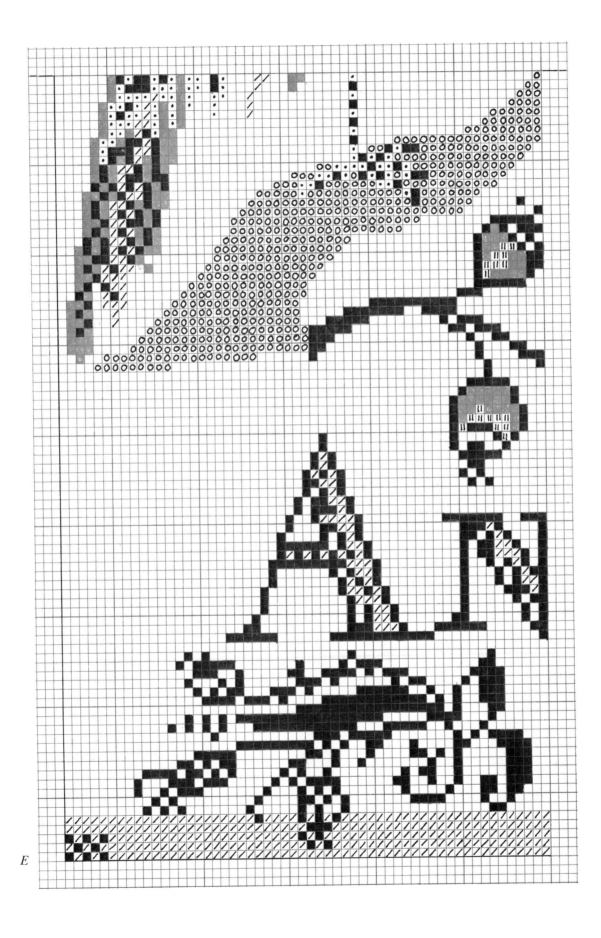

E

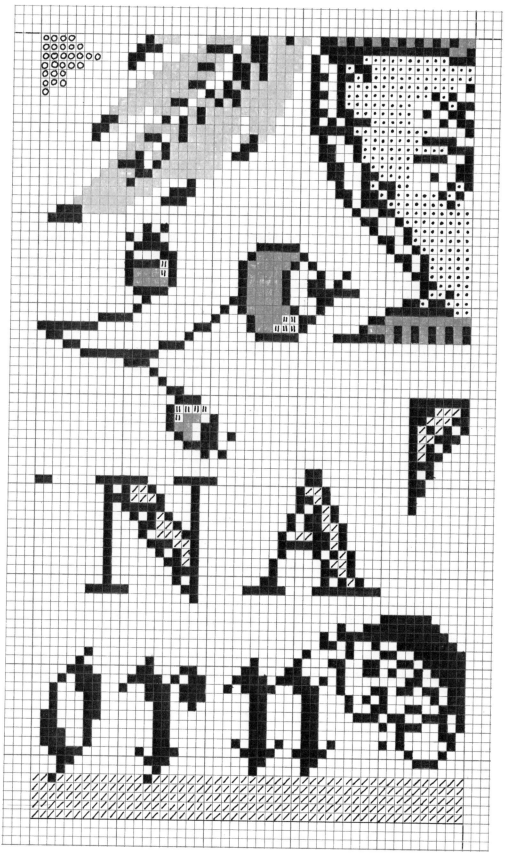

F

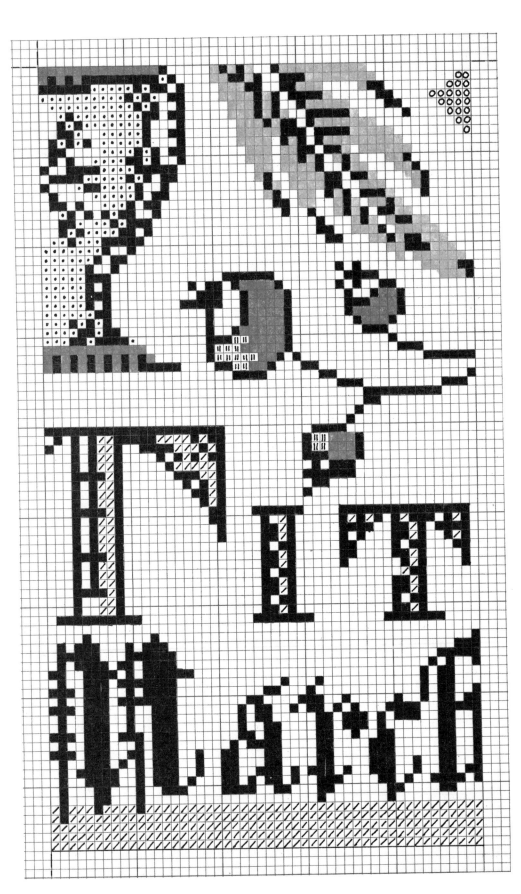

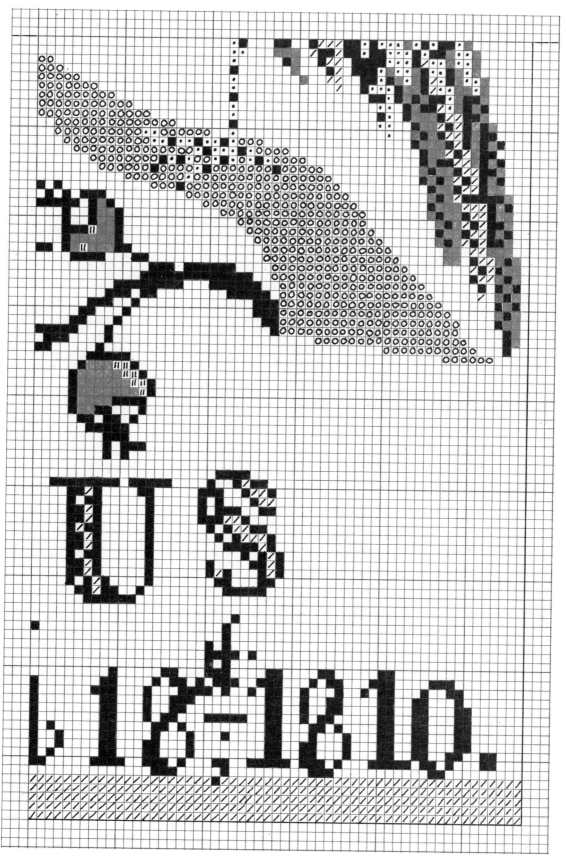

H

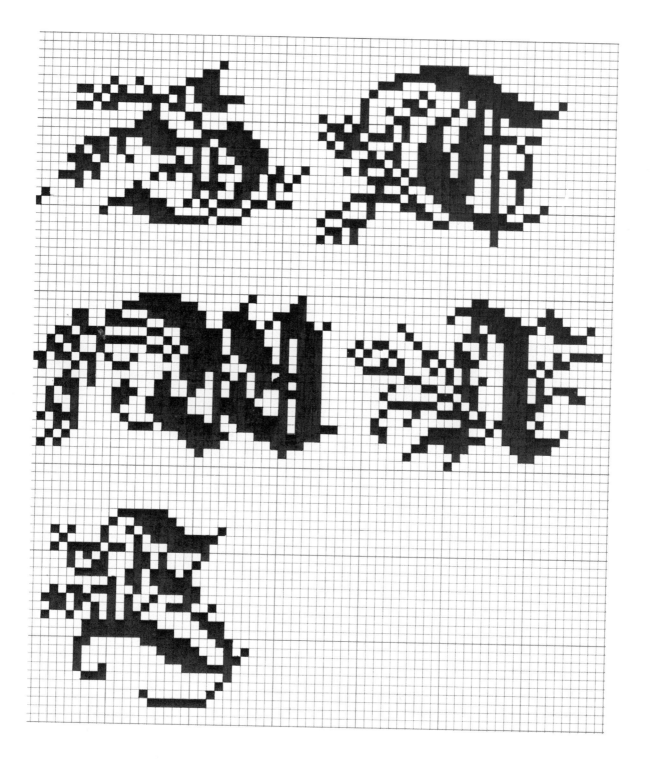

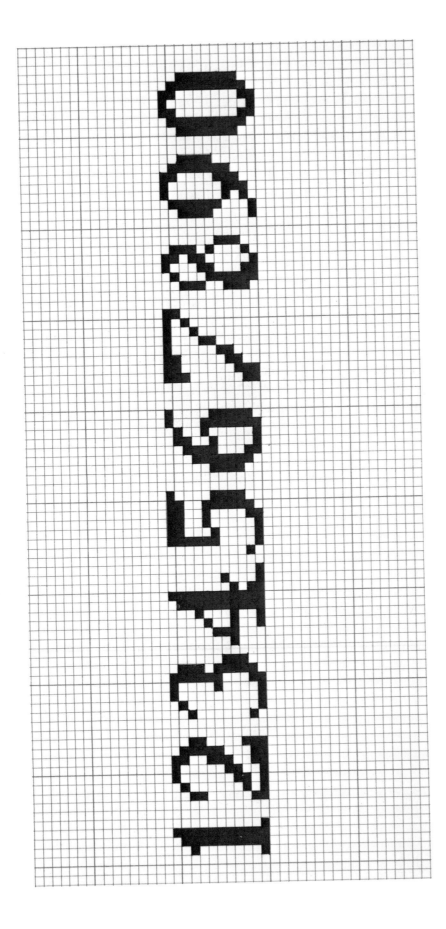

The American War Horse

In the first quarter of the nineteenth century, an unknown artist used watercolor, graphite, and stencils to execute *The American War Horse*. This painting, which measures 17⅞ inches by 23 inches, was found in Ohio, and is now part of the collection of Edgar William and Bernice Chrysler Garbisch. Amateur watercolorists of the time frequently used patriotic themes for their subjects. The words "The American War Horse" are inscribed with an elaborate flourish across the bottom of the picture, and "E. Pluribus Unum" appears on the pennant with the American flag. Since the large number of stitches in these areas wouldn't permit a clear rendering in the regular needlepoint stitch, I've included drawings that show these details as they appear on the original (page 88). I like the illusion that resulted when it was put into graph form, but you might like to make it clearer on your canvas. If so, simply ignore the graph in these areas and fill in those stitches with the background color. After that you can go back and embroider the phrases over the needlepoint, using wool or embroidery floss in the same color you would have used according to the graph.

The needlepoint sample was worked by Beka Martin, Judy Gordan, and Betty McDonnell.

Thread Count: 127 x 169

Canvas Gauge	Approximate size
#18	7 inches x 9½ inches
#14	9 inches x 11¾ inches
#10	12 inches x 16⅝ inches
#5	25½ inches x 33⅜ inches

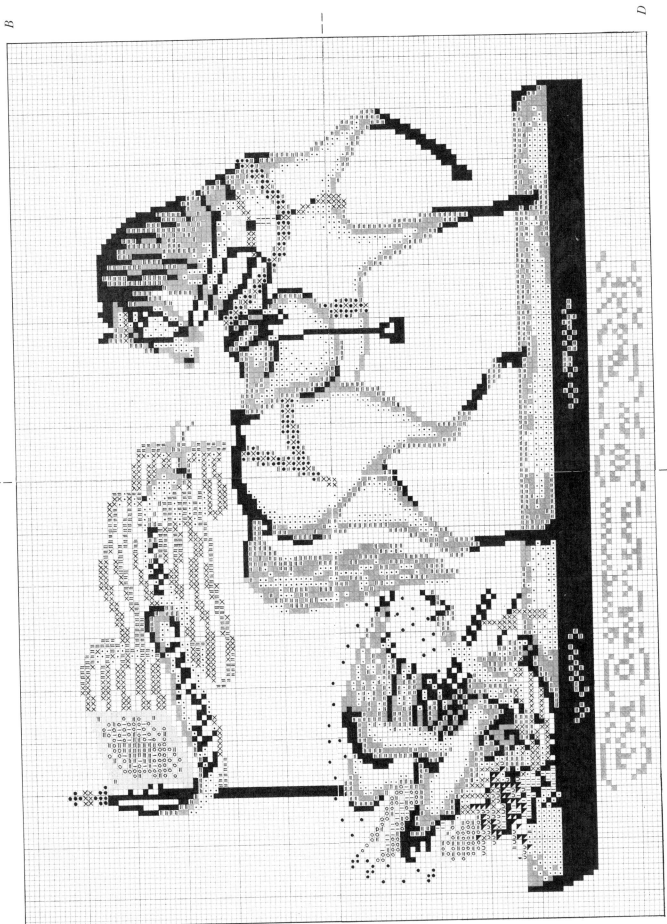

Light brown #138 • ∽ #312 Dark blue

Medium brown #132 ▨ ∪ #526 Green

Dark brown #116 = ▨ #524 Dark green

Darkest Brown #112 ■ X #R80 Light red

Yellow #441 ● || #R69 Red

Medium blue #752 ○ Blank #014 Beige

Aqua #783 |

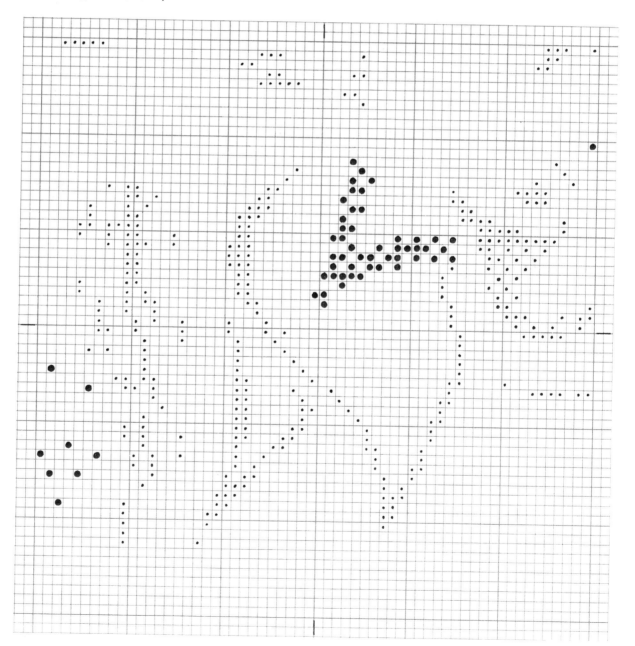

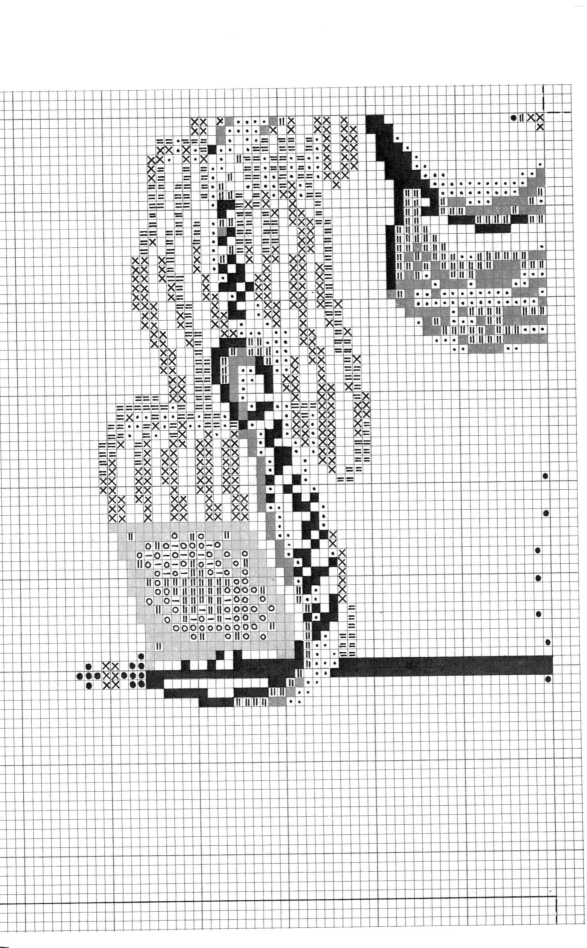

B

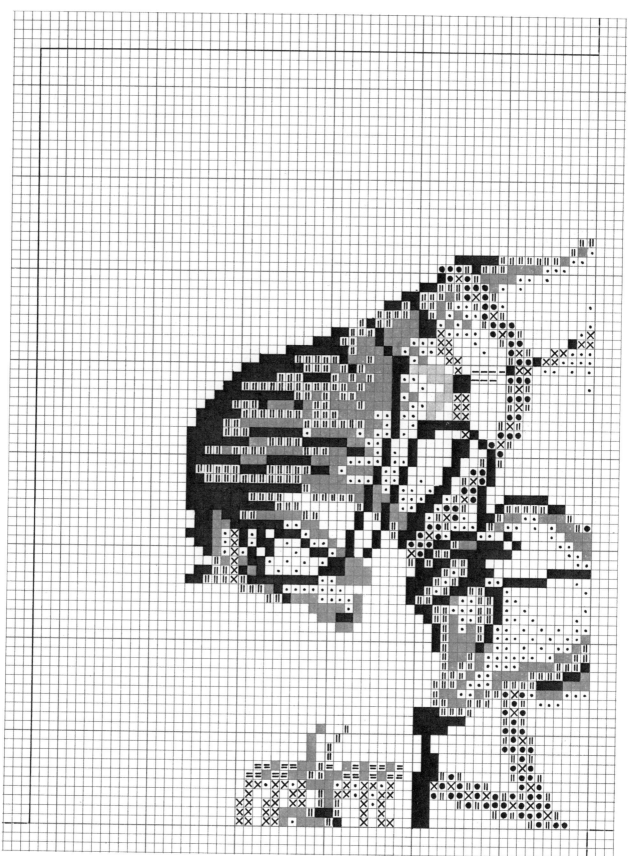

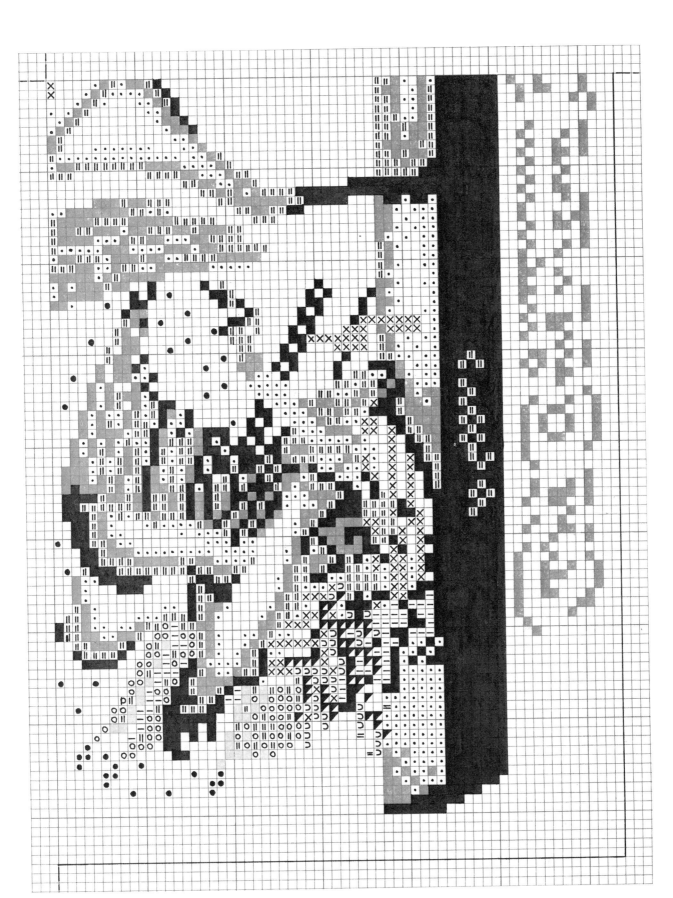

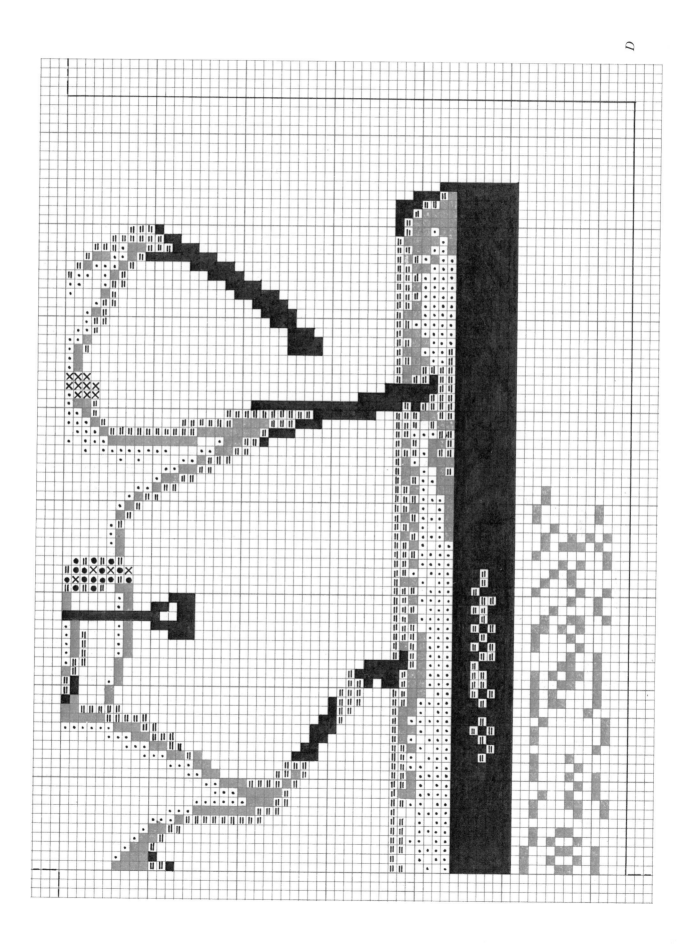

Cat in a Window

Painted by an unknown artist around 1880–1890, *Cat in a Window* was done with oils on a 22½-by-31¼-inch canvas. It now belongs to a private collector. Although primitive artists seldom attempted to paint realistically, this is one of the few successful examples of *trompe l'œil* ("fool the eye") that has surfaced. It is a picture of a cat sitting serenely on a window ledge in front of a bluish green hatbox and next to an assortment of pottery, including a small decorated pitcher.

The needlepoint sample was worked by the author.

Thread Count: 144 x 104

Canvas Gauge	Approximate Size
#18	8⅛ inches x 5⅝ inches
#14	10¾ inches x 7¾ inches
#10	14¼ inches x 9¾ inches
#5	28½ inches x 20¾ inches

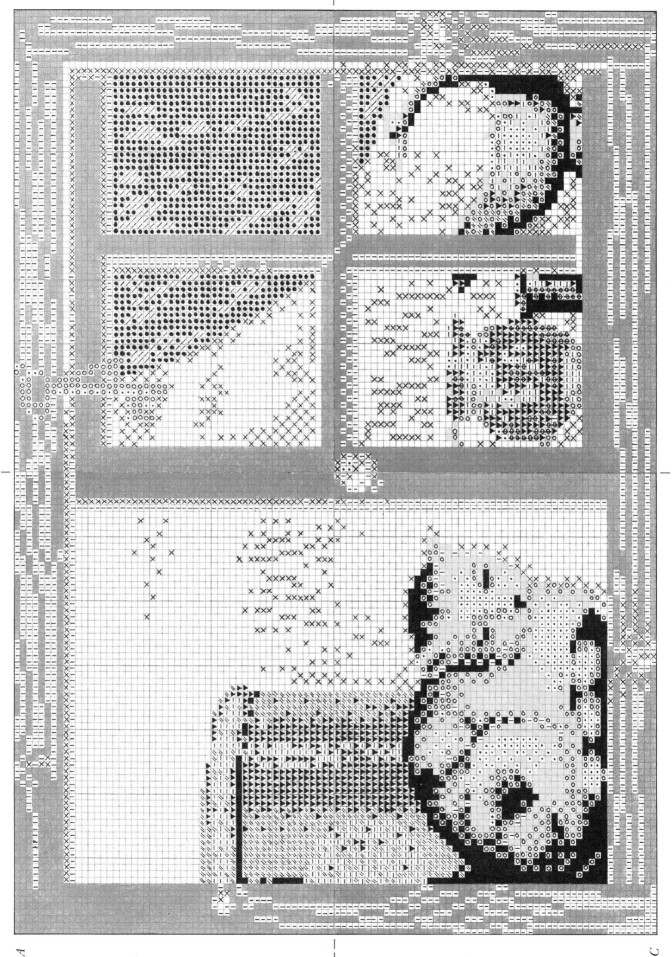

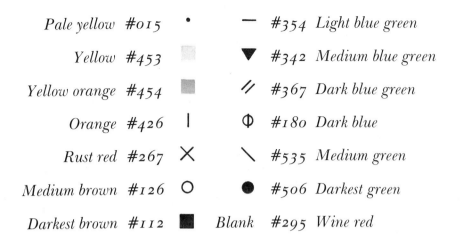

Pale yellow #*015* • — #*354* *Light blue green*

Yellow #*453* � ▼ #*342* *Medium blue green*

Yellow orange #*454* // #*367* *Dark blue green*

Orange #*426* | Φ #*180* *Dark blue*

Rust red #*267* ✕ \ #*535* *Medium green*

Medium brown #*126* ○ ● #*506* *Darkest green*

Darkest brown #*112* *Blank* #*295* *Wine red*

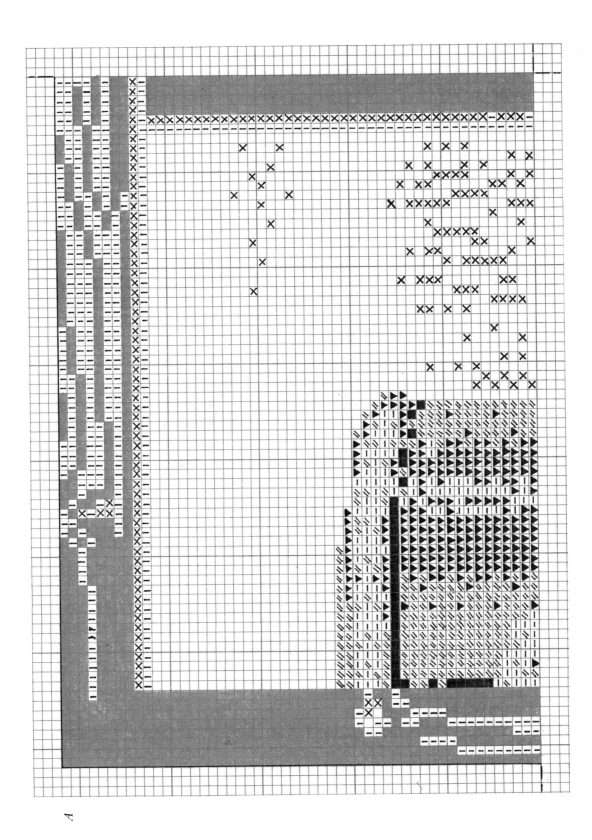

B

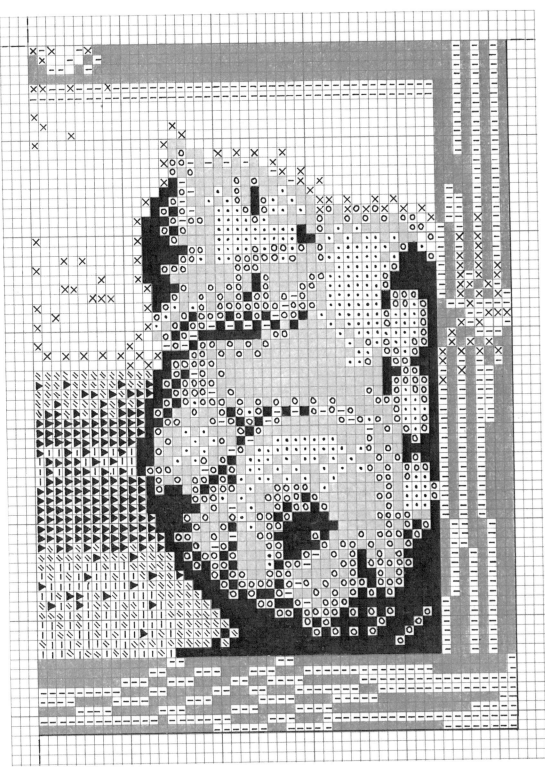

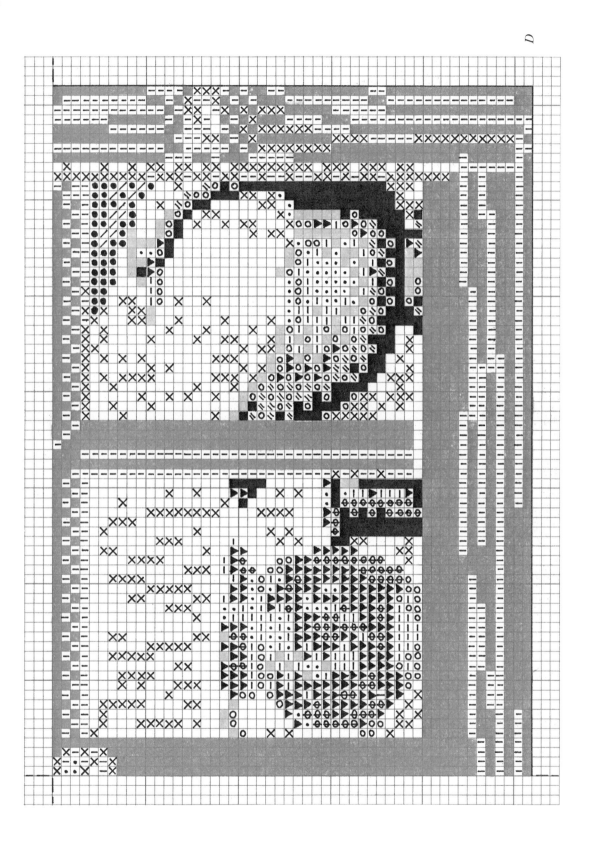

Stylized Bird

This painting was found in Pennsylvania, and was probably painted in the first half of the nineteenth century. It falls into the category of still life, and was executed with stencils and watercolors by an anonymous artist. The original painting is 17⅛ inches by 14⅜ inches and is from the collection of Edgar William and Bernice Chrysler Garbisch.

The needlepoint sample was worked by Ina Zoob.

Thread Count: 162 x 129

Canvas Gauge	Approximate Size
#18	8¾ inches x 7¼ inches
#14	11½ inches x 9⅛ inches
#10	15¼ inches x 12¾ inches
#5	32½ inches x 25½ inches

Yellow	#467	Z	•	#837	Pale pink			
Gold	#453	U	/	#831	Medium pink			
Dark gold	#433	◣					#288	Dark pink
Light gray	#168	O	—	#354	Light blue green			
Medium gray	#166	X	I	#566	Light yellow green			
Dark gray	#164	=		#532	Medium blue green			
Darkest gray	#162	■	●	#527	Medium yellow green			
Dark green	#506	▨	Blank	#012	Off-white			

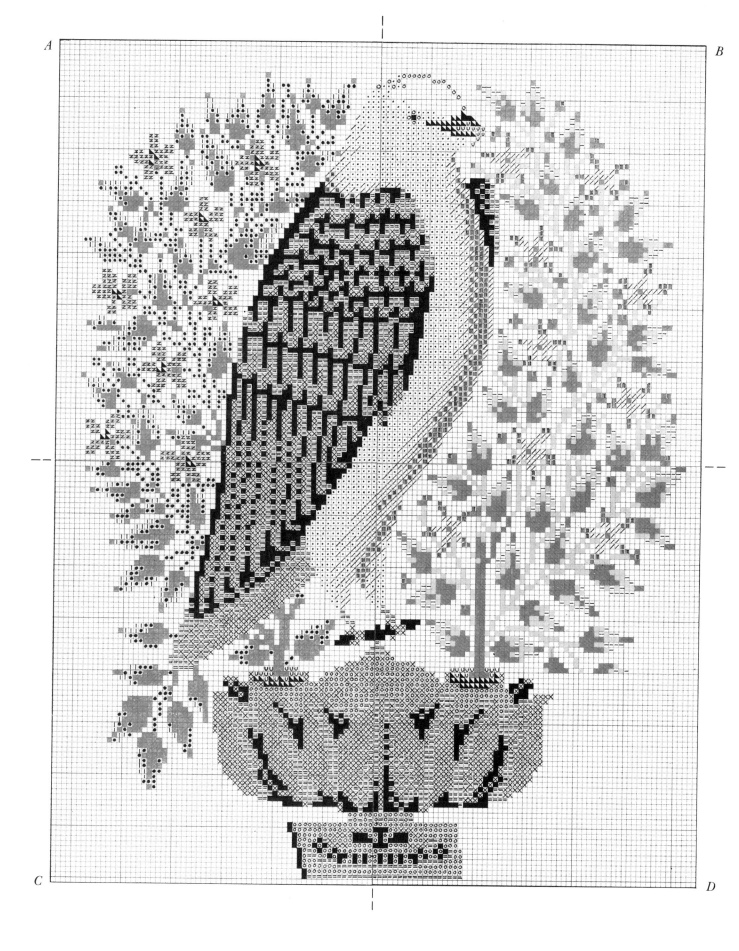

A

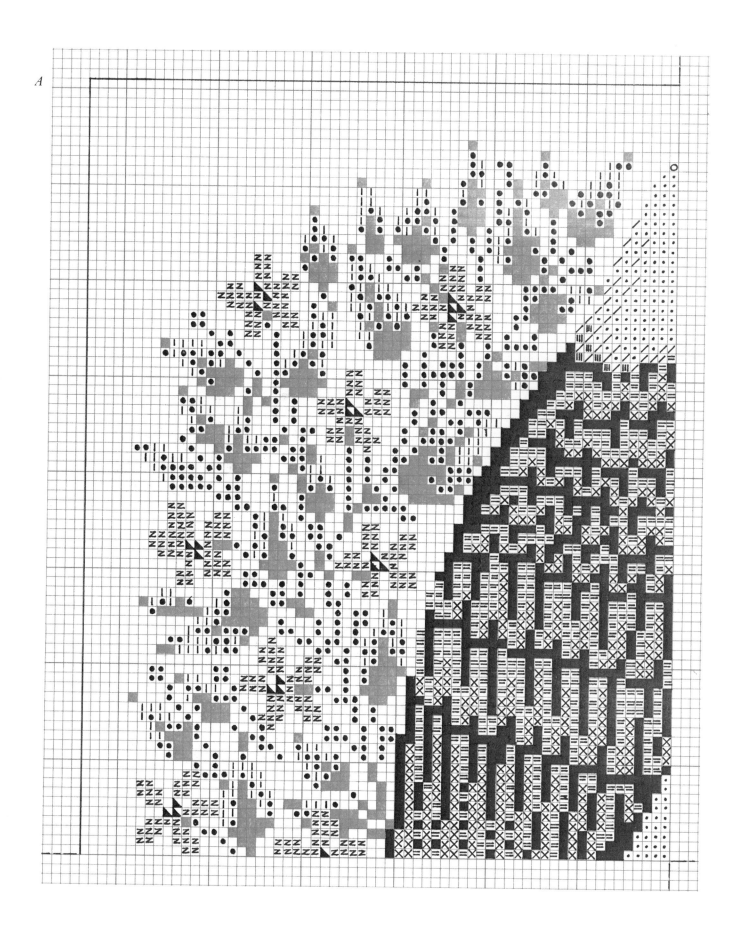

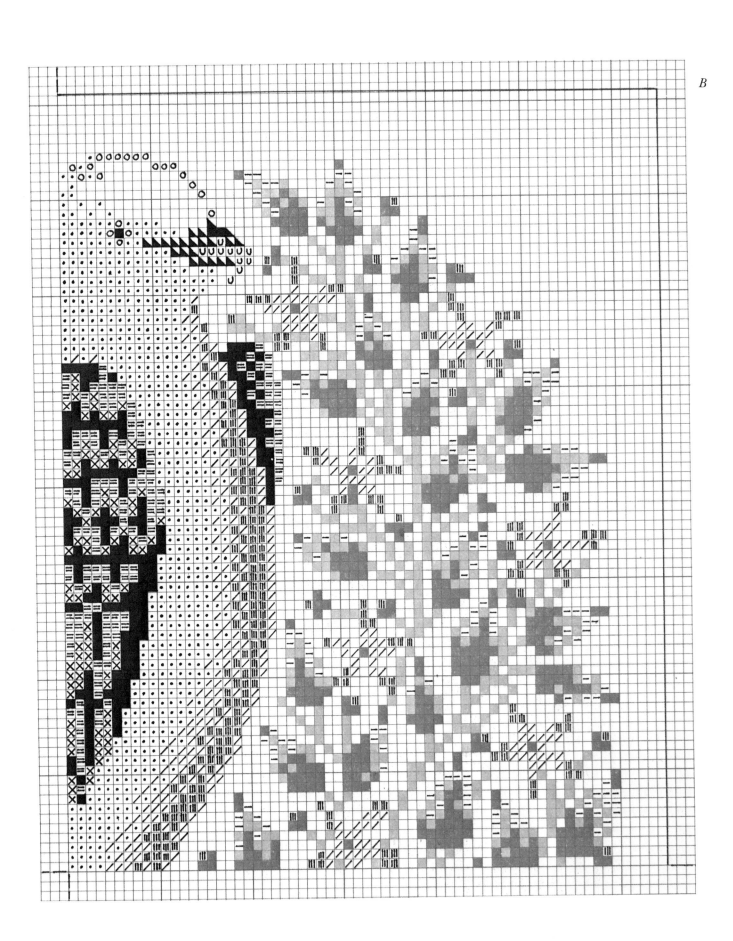

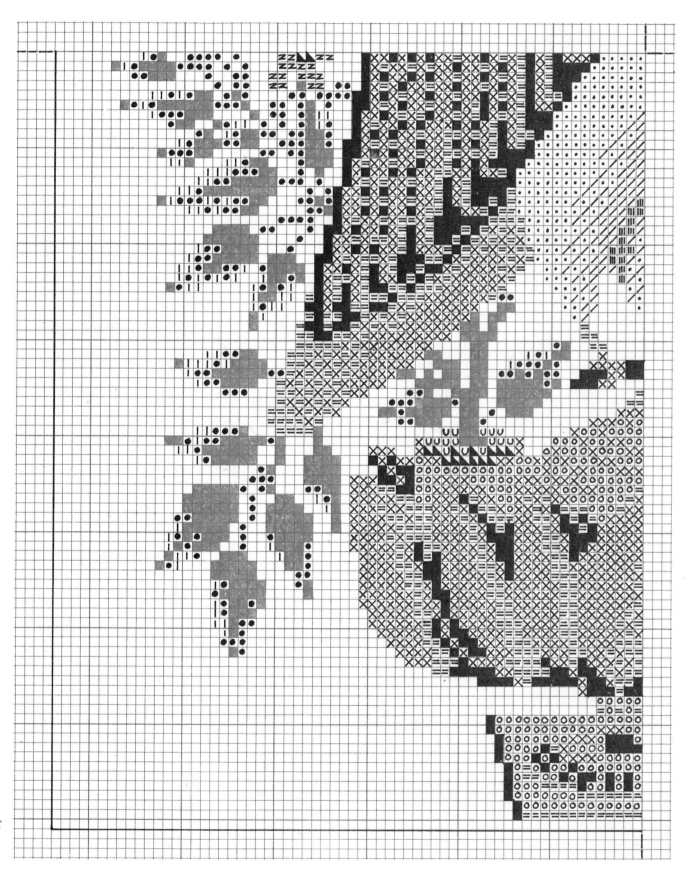

C

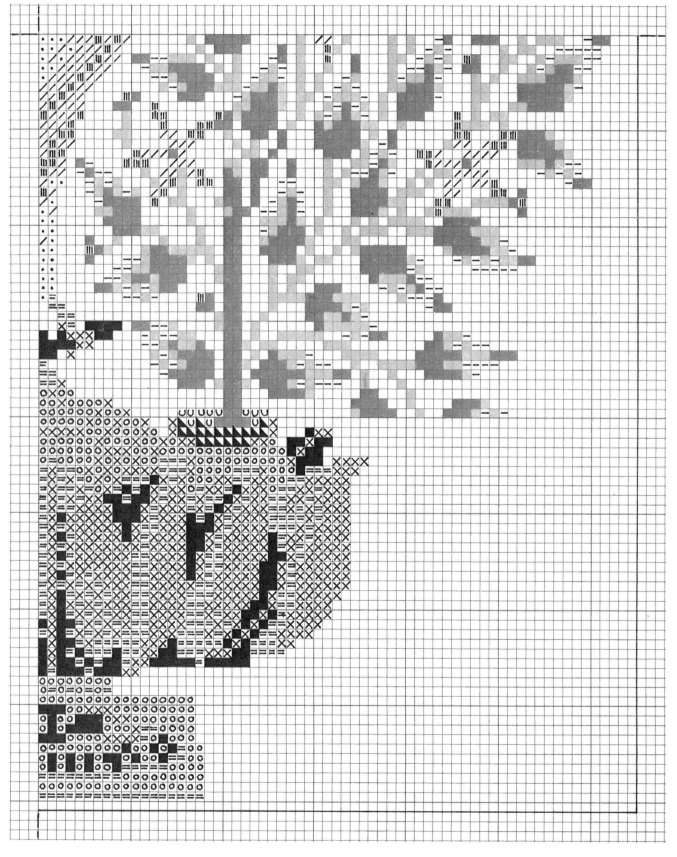

D

Melons
and Other Fruit

Designs like this one were commonly produced by
young students from stock stencils that supplied even
detailed instructions for which colors to use. This one
was done sometime between 1840 and 1850 by an un-
known artist, probably a student. It is 12 inches by 16
inches, was produced with watercolors on paper, and is
from the Abby Aldrich Rockefeller Folk Art Collec-
tion, in Williamsburg, Virginia.

The needlepoint sample was worked by Beka
Martin.

Thread Count: 133 x 162

Canvas Gauge	Approximate Size
#18	7¼ inches x 9⅛ inches
#14	9½ inches x 11½ inches
#10	12½ inches x 16 inches
#5	26½ inches x 32 inches

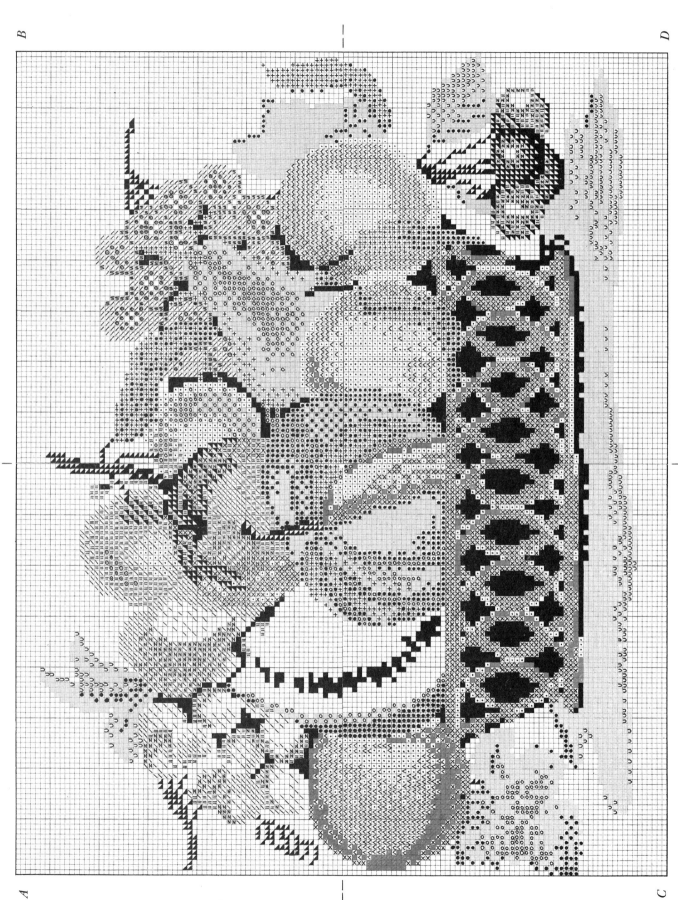

Pale yellow	#496	·	◀	#285	Dark pink
Medium yellow	#541	∧	◣	#025	Tan
Red orange	#273	✕	∪	#566	Light yellow green
Orange	#423	▨	○	#556	Light green
Lavender	#641	⊙	░	#342	Medium blue green
Purple	#117	╲	+	#522	Medium green
Dark blue	#180	S	●	#340	Dark green
Beige	#153	╱	■	#180	Dark gray
Dusty pink	#143	‖	Blank	#014	Off-white
Pink	#898	Z			

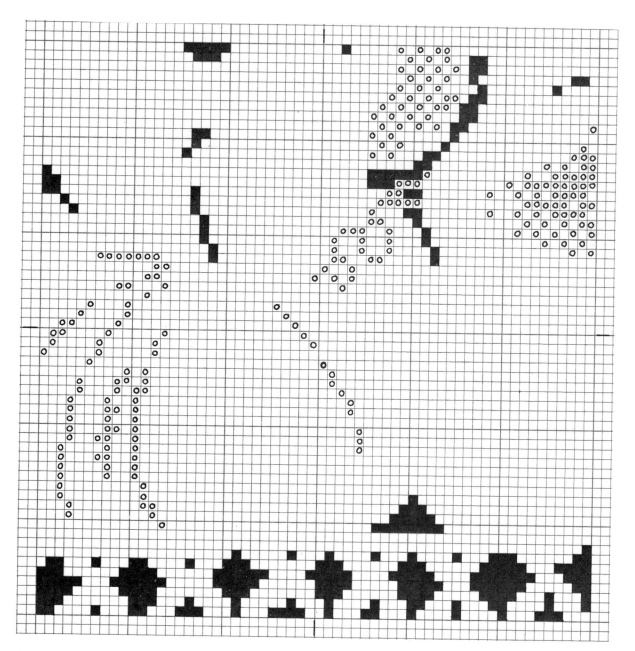

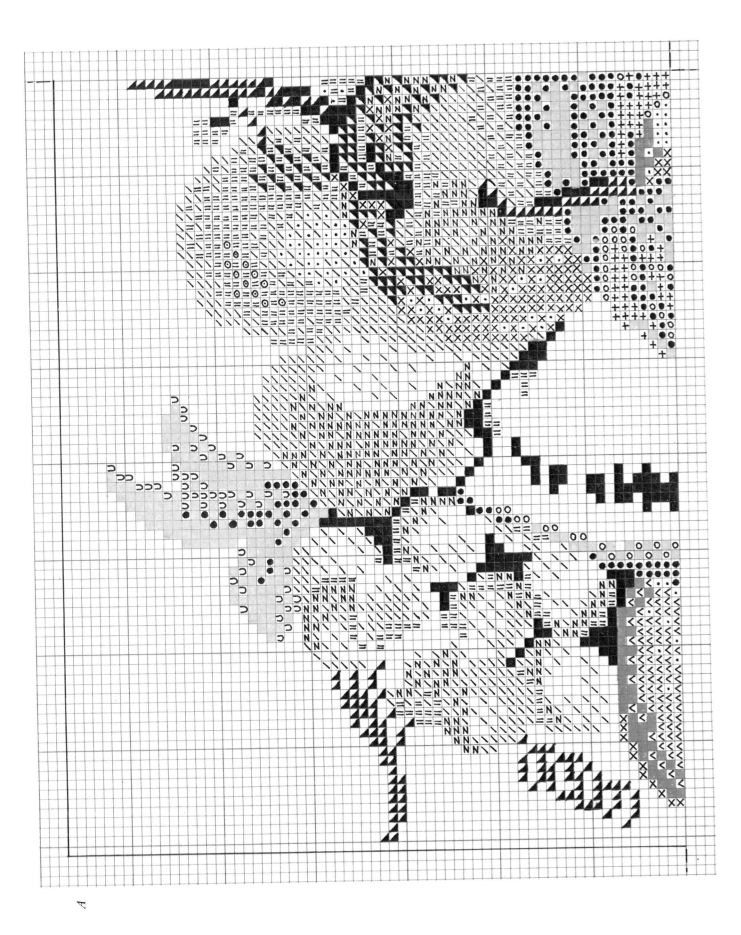

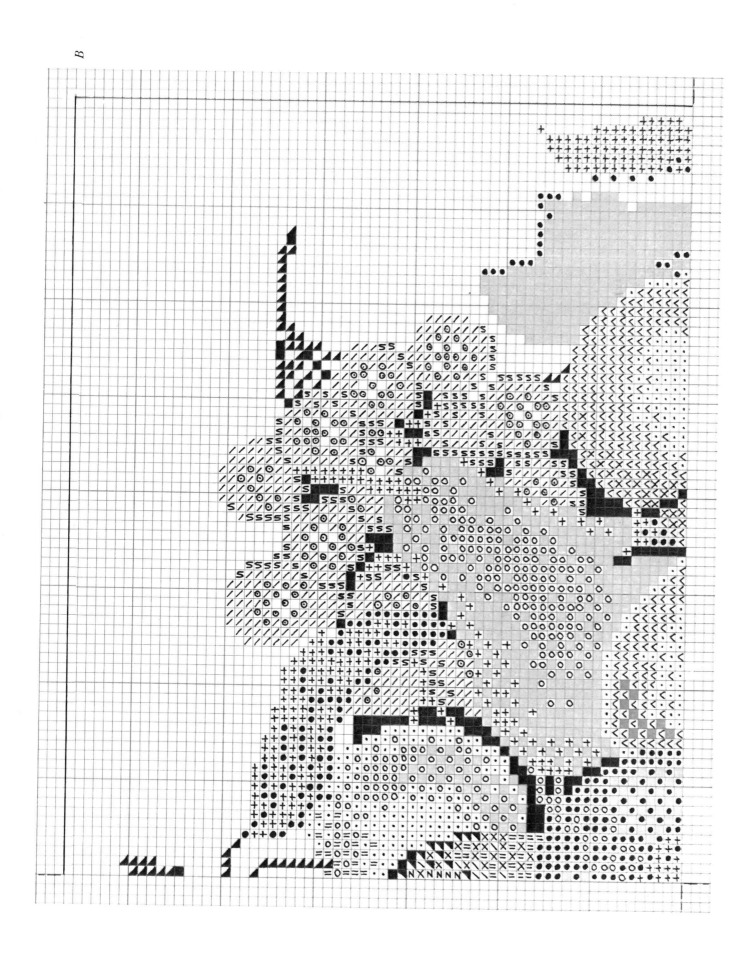

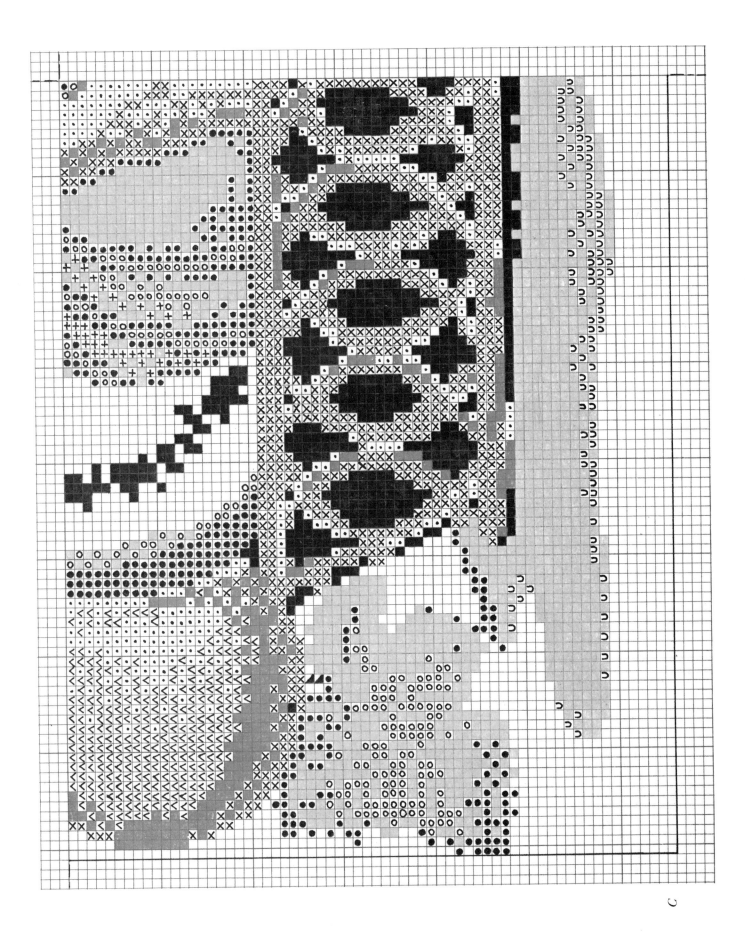

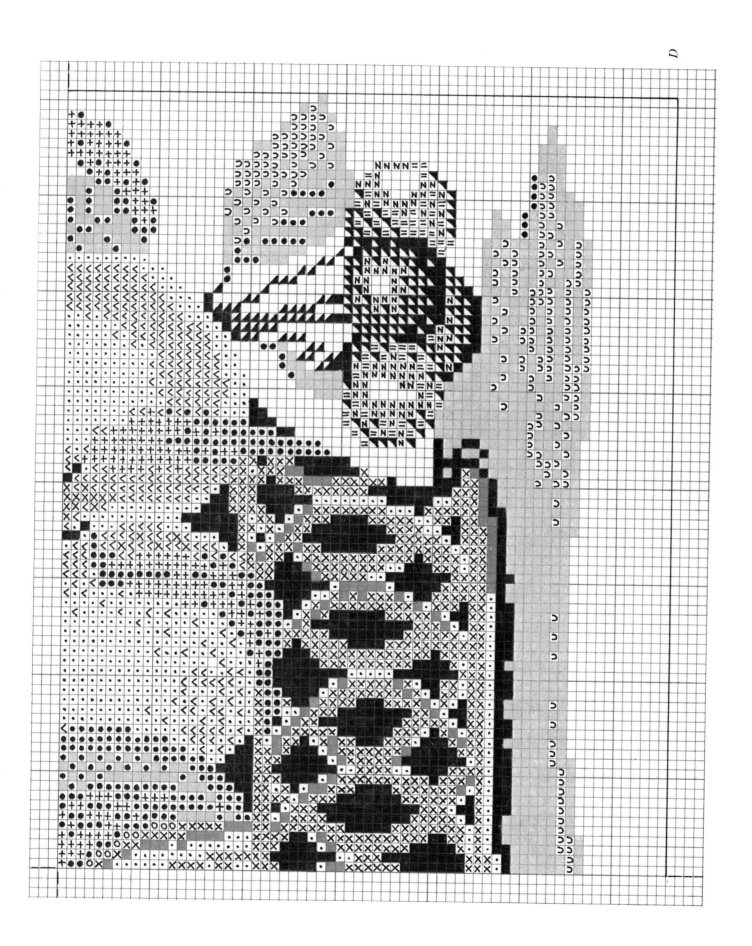

D

Chilly Observation

This is a delightful painting of a smiling polar bear sitting on an ice floe and observing three distant ships. It was done by one of our few well-known folk painters, Charles S. Raleigh, in 1889.

Raleigh was born in 1831 in Gloucester, England. At the tender age of ten, he was lured away from home by the sea. He fought in the U.S. Navy during the Mexican War, and later became a merchant seaman. In 1870 he went to Bourne, Massachusetts, took a wife, and moved to New Bedford, Massachusetts, working there as a house painter and decorator. In 1877 he became confident enough to establish a studio, painting marine subjects until 1881, when he returned to Bourne. After a while his eyesight began to fail. He died at the age of ninety-four, in 1925.

The painting was executed in oils on a 44¹⁄₁₆-by-30-inch canvas. It belongs to the Philadelphia Museum of Art, a gift of the Garbisches.

The needlepoint sample was worked by Elaine Ormond and Ted Theodore.

Thread Count: 163 x 116

Canvas Gauge	Approximate Size
#18	9⅛ inches x 6⅜ inches
#14	11½ inches x 8¼ inches
#10	16 inches x 11 inches
#5	32¼ inches x 22½ inches

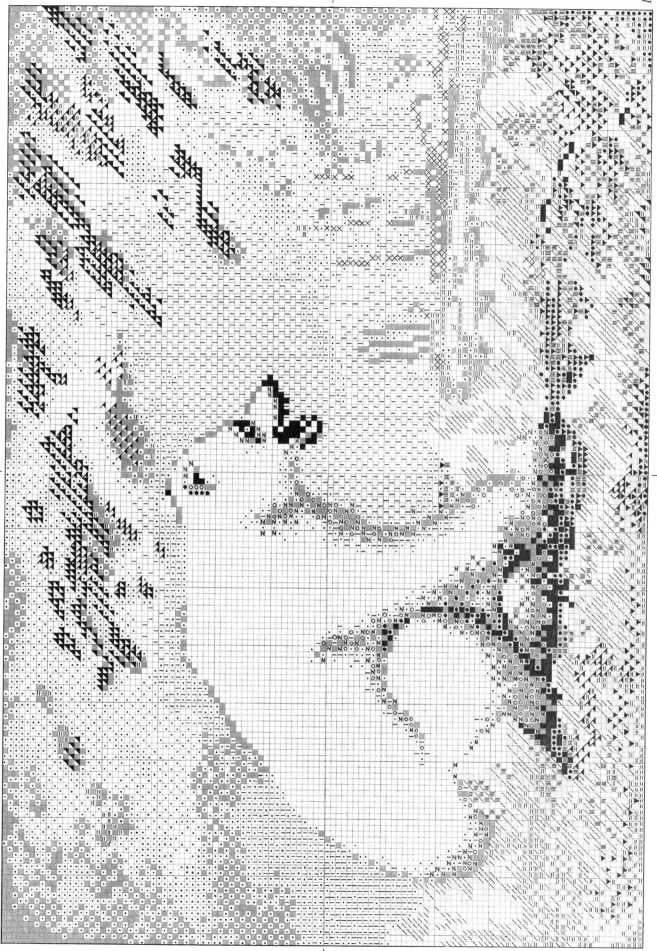

Pale pink	#014	│				#138	Beige
Dusty pink	#143	○	▼ #249	Tan			
Pale gray	#168	•	● #113	Brown			
Medium gray	#164	▦	◢ #781	Light blue			
Dark gray	#162	✕	◣ #332	Medium blue			
Darkest gray	#108	■	Z #184	Lavender gray			
Pale gray green	#032	╱	= #380	Dark blue gray			
Medium gray green	#391	Blank	#005	White			

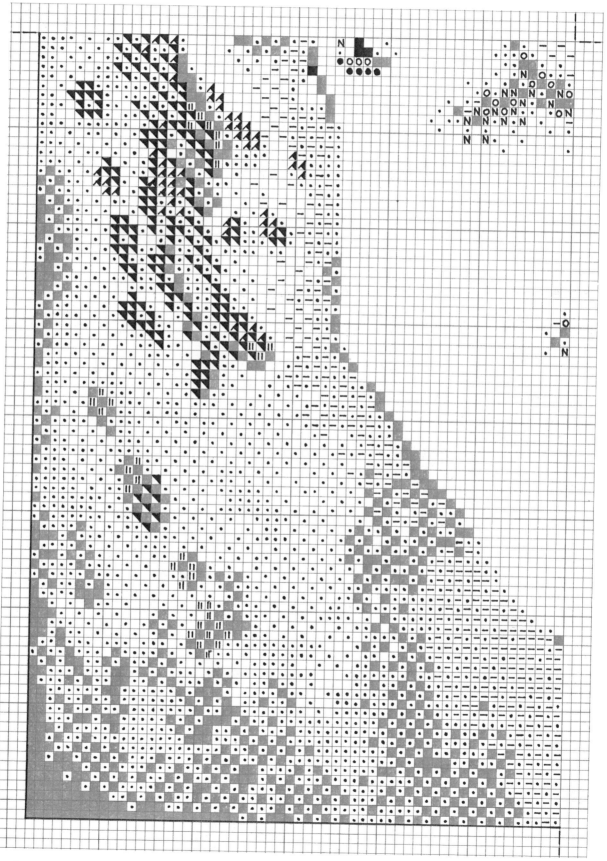

A

B

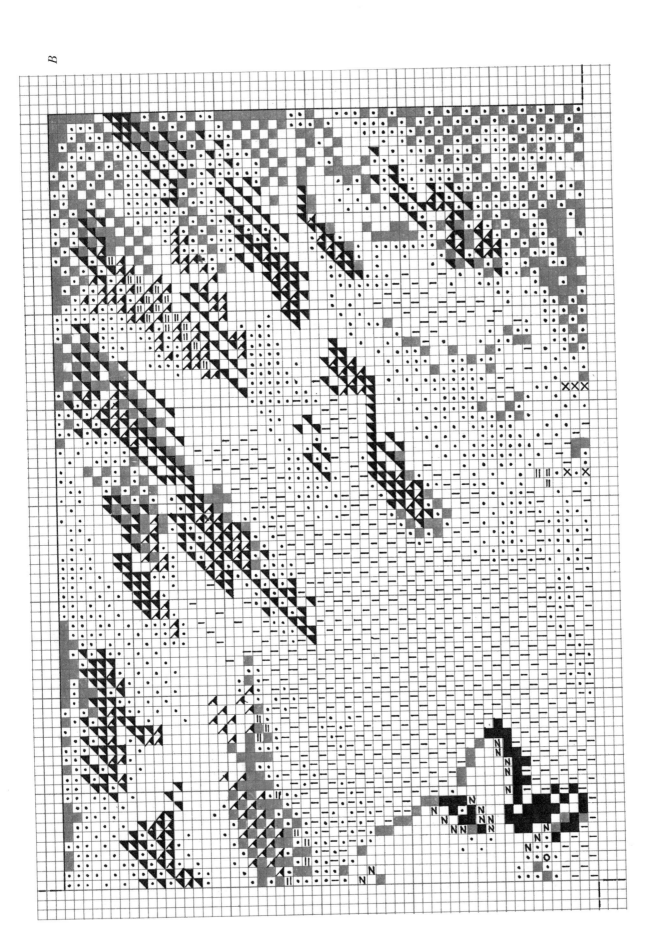

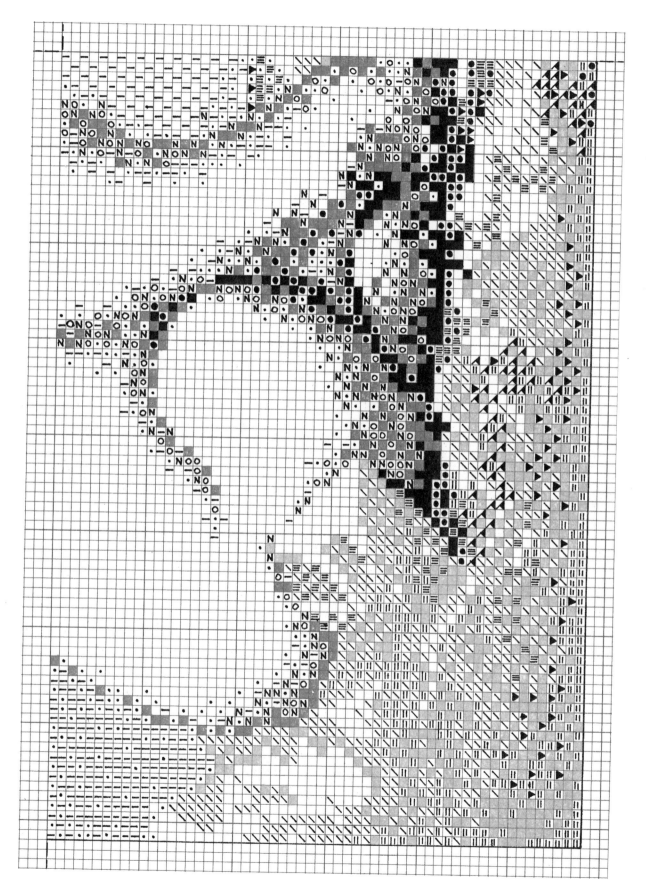

D

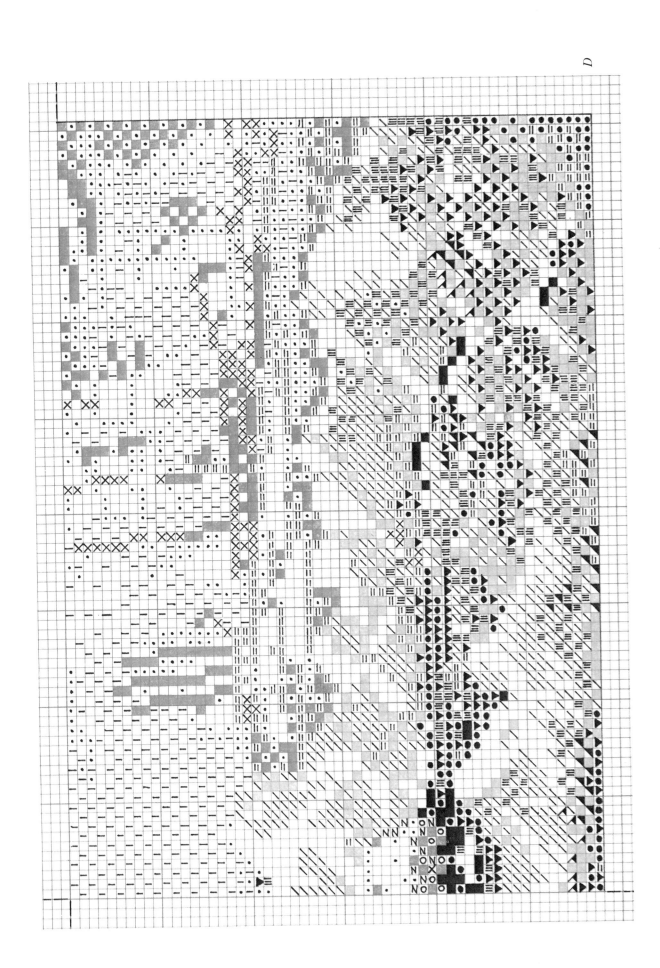

Peaceable Kingdom

This painting of the Peaceable Kingdom, painted in 1884, is one of almost a hundred canvases on the theme by Edward Hicks.

Hicks was born in Attleborough, Pennsylvania, on April 4, 1780. He was apprenticed to a coachmaker for seven years before he went into a partnership with another coachmaker and sign painter. In 1803, young Hicks took a wife and became a Quaker, and then a preacher of the faith. He spent the better part of his life in Newton, Pennsylvania, traveling around the countryside, making his living by preaching and doing ornamental painting. He died on August 23, 1849.

Although in the earlier years of this country Quakers felt that painting or drawing was a waste of time and therefore ungodly, Hicks maintained a philosophy that would keep his painting within the bounds "of innocence and usefullness." This explains why much of his voluminous work has a religious theme. Hicks was also fascinated with William Penn, and frequently included a vignette of Penn making his famous treaty with the Indians. If you hold the color plate at arm's length, you will be able to see this little scene in the center of the far left-hand side of the painting. Hicks greatly admired Penn, and believed that his "Holy Experiment" was the fulfillment of Isaiah's prophecy: "The wolf also shall dwell with the lamb, and the leopard shall lie down with the kid; and the calf and the young lion and the fatling together; and a little child shall lead them." Edward Hicks is now world-famous for his many paintings of the Peaceable Kingdom, most of which he made as gifts to friends. Many of these paintings are very similar to one another, with subtle differences in the look and positioning of the

Fig. 2

animals and other elements. This particular one is from the Abby Aldrich Rockefeller Folk Art Collection, Williamsburg, Virginia.

In Fig. 2 the shaded area above the line indicates the placement of the ice blue background color. All blank spaces on the graph below this line should be off-white.

The needlepoint sample was worked by the author and her mother, Elaine Ormond.

Thread Count: 163 x 203

Canvas Gauge	Approximate Size
#18	8⅞ inches x 11½ inches
#14	11½ inches x 14¾ inches
#10	15⅜ inches x 20 inches
#5	32⅝ inches x 40 inches

Pale aqua	#354	I	O	#462	Dark ochre
Light chartreuse	#575	∽	/	#145	Darkest ochre
Chartreuse	#570	◣	—	#116	Brown
Medium green	#527	▨	■	#110	Darkest brown
Green	#520	●	X	#843	Red
Stone green	#563	⊘	=	#215	Rust
Taupe	#025	‖‖	Z	#274	Light rust
Tan	#492	▥	∷	#G30	Blue green
Pale ochre	#453	·	Blank {	#012	White*
Ochre	#445	➤	{	#032	Ice blue

*See Fig. 1 for the distribution of the background colors.

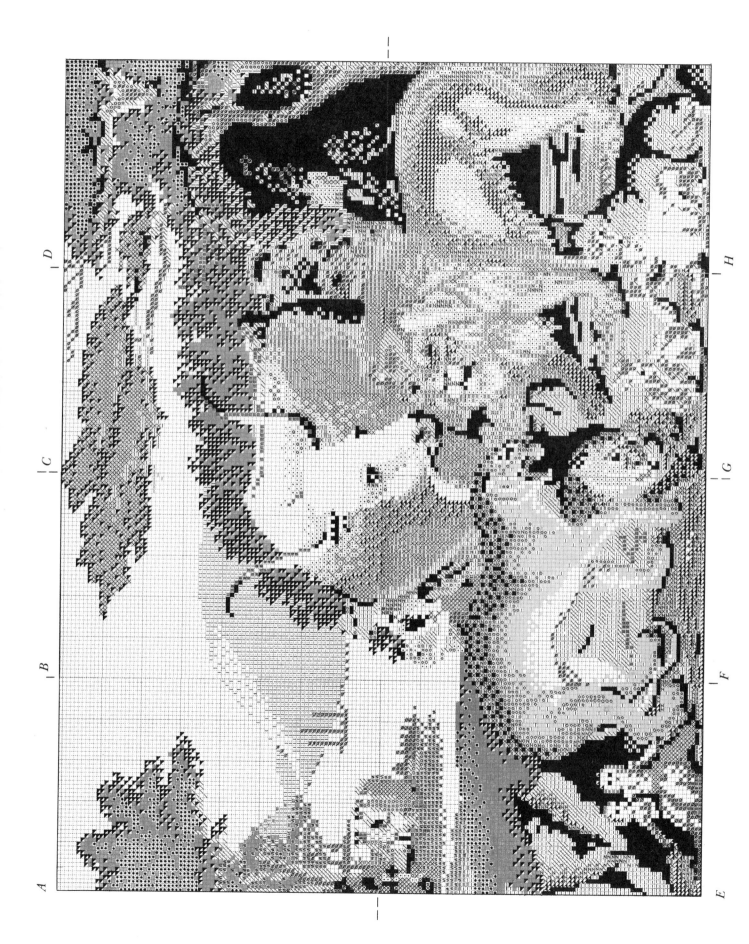

A

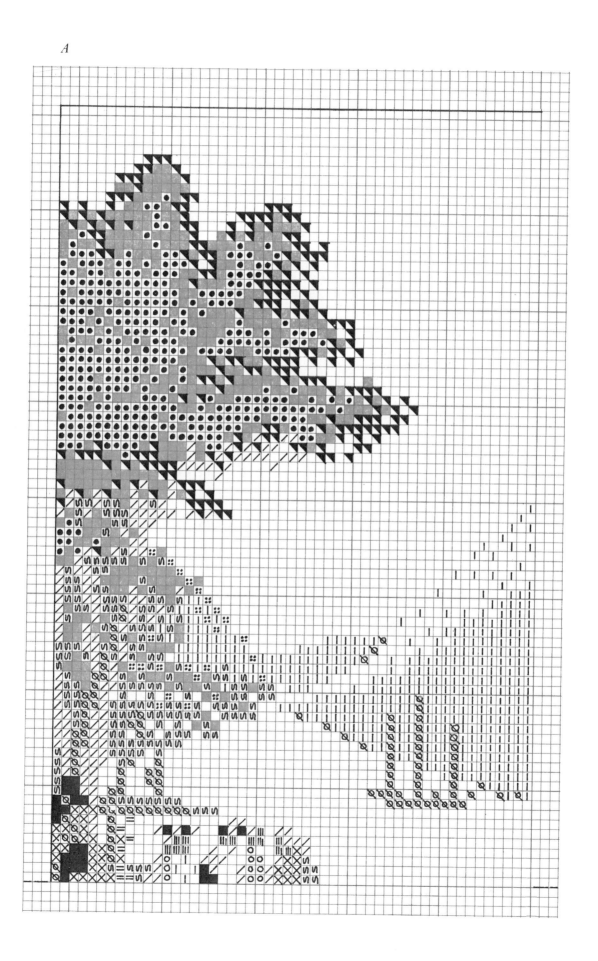

B

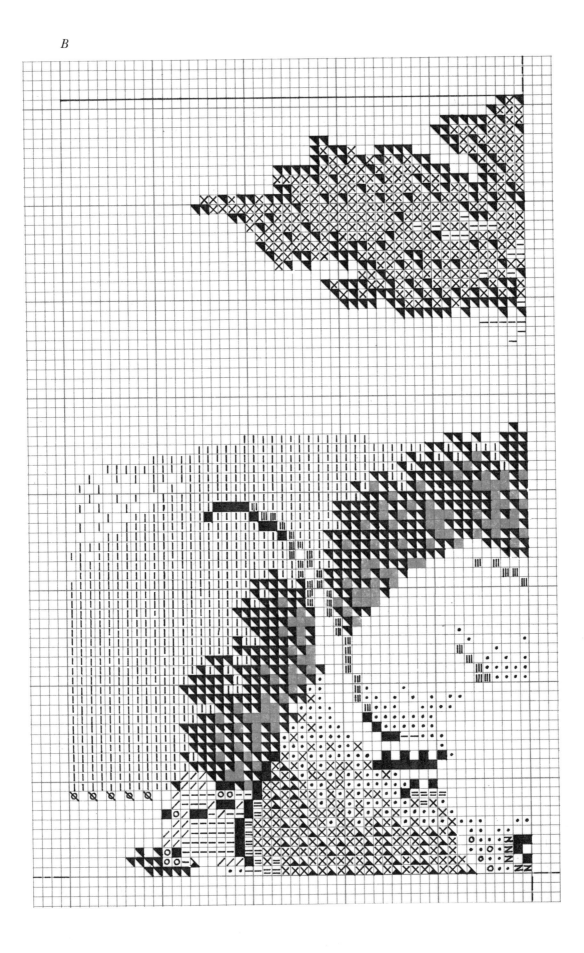

C

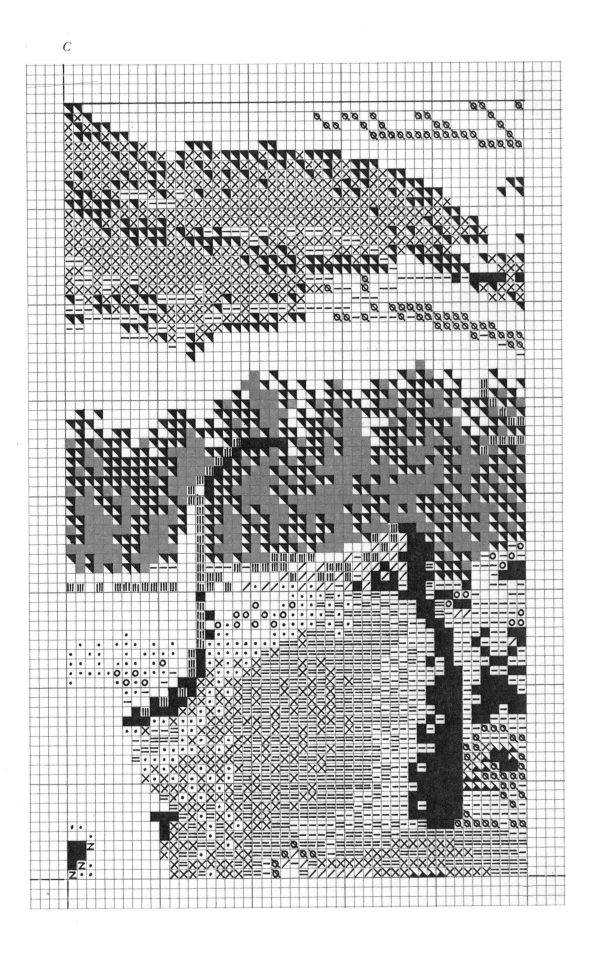

D

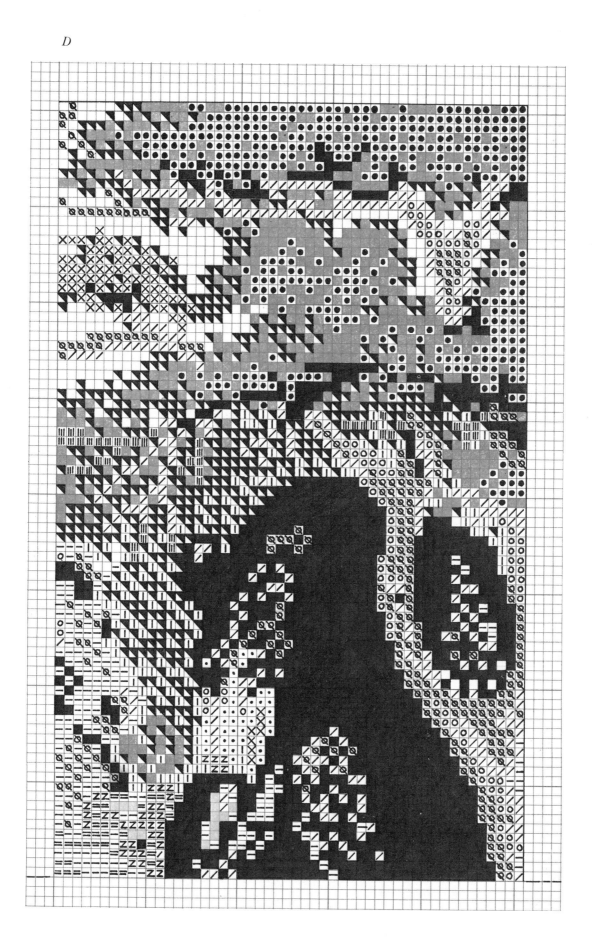

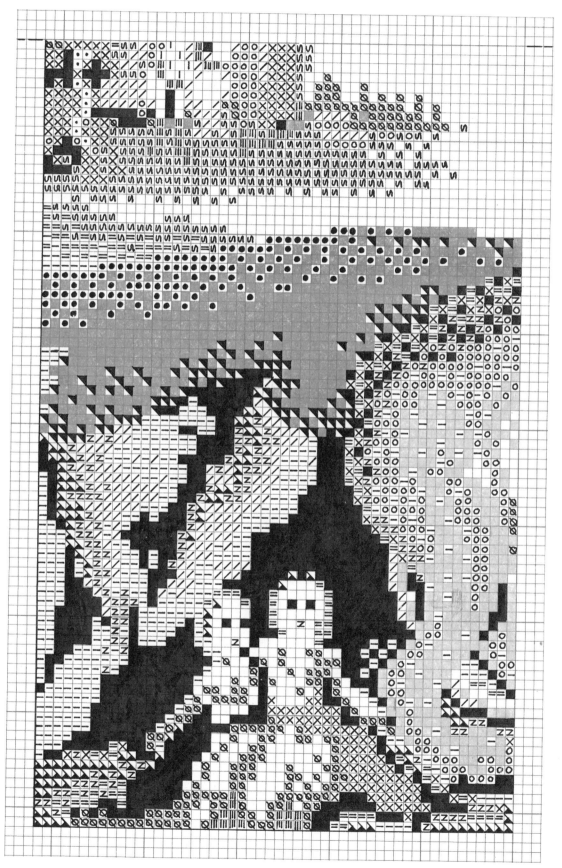

E

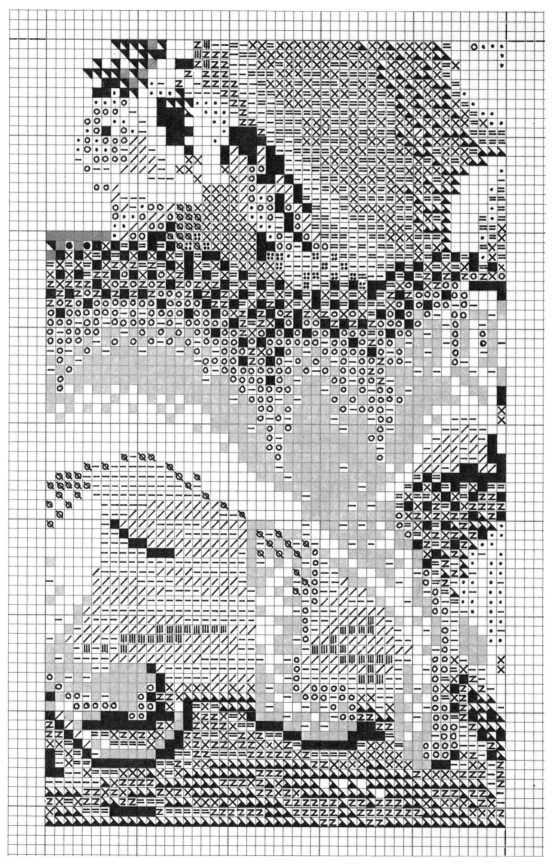

F

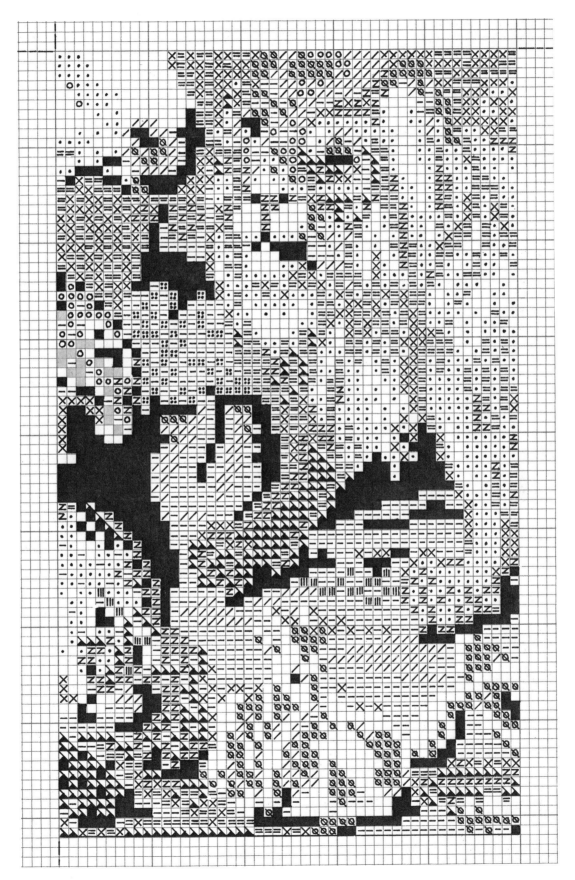

G

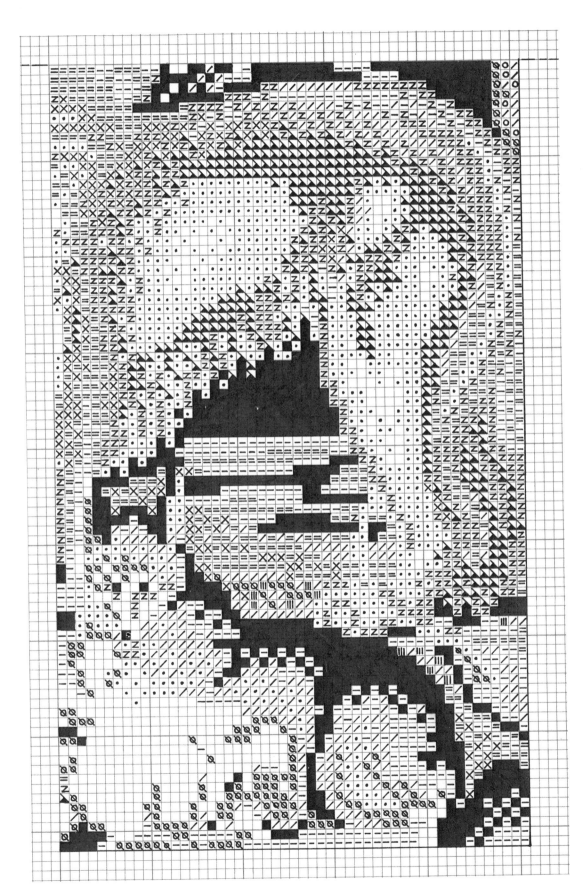

H

Borders

For those who wish to add to their canvases for practical or aesthetic purposes, I've graphed fourteen borders that I feel are appropriate to the designs in this book. Most of these were taken from frakturs and woven coverlets, and have been slightly altered to adapt to graph form. Some are simple; others are elaborate. As to which borders "go with" which design, your only criterion should be what appeals to your personal tastes. You may feel your design should be handled simply, with a plain border, or you may prefer to have it richly embellished, with several borders. Either choice is correct so long as you like the way the whole canvas looks. There are two things I would suggest that you keep in mind while doing this planning: (1) for any but the simplest designs, allow some "breathing space" of several rows of plain color between the design and the border, and (2) choose colors from the ones used in the design itself. To help you decide which colors to use, spread out the hanks of wool you have for the design so that you can see them all at once. Then try different combinations until you hit on one you like. You are not limited by the number of colors represented on the graph; you can make any changes you wish, like reversing darks and lights or perhaps alternating two colors where there is just one on the graph.

Under each graphed border is a broken line, which marks the center of one repeat, and arrows indicating the whole repeat. The line and arrows will help you with the placement and counting of the stitches, but in most cases you don't need to worry about precise centering. Lay out the border — on graph paper, if you wish — one side at a time, counting from the center out to the corners. See Fig. 1. If the border isn't sym-

center

count to corners

center

design area

metrical from top to bottom, turn the canvas upside down and count the border on the opposite side. The pattern should have the same edges facing out. When you come to the corners, simply let the patterns come together as they will. This was often the way primitive artists handled the problem of corners, and it is certainly the least complicated solution.

Each graphed border has the same kind of chart, showing thread counts and widths in inches for each of the recommended canvas gauges. The chart will help you figure what size to cut the canvas at the start of your project.

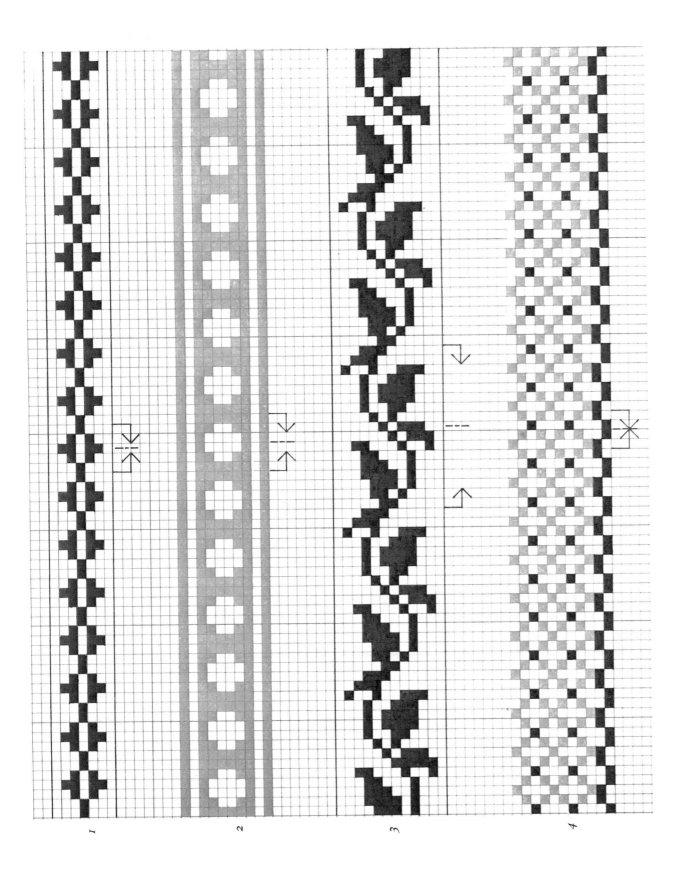

1

2

3

4

1. 7 stitches wide

Canvas Gauge	Approximate Width
#18	⅜ inch
#14	½ inch
#10	¾ inch
#5	1½ inches

2. 10 stitches wide

Canvas Gauge	Approximate Width
#18	½ inch
#14	¾ inch
#10	1 inch
#5	2 inches

3. 12 stitches wide

Canvas Gauge	Approximate Width
#18	⅝ inch
#14	⅞ inch
#10	1⅛ inches
#5	2¼ inches

4. 11 stitches wide

Canvas Gauge	Approximate Width
#18	⅝ inch
#14	¾ inch
#10	1⅛ inches
#5	2⅛ inches

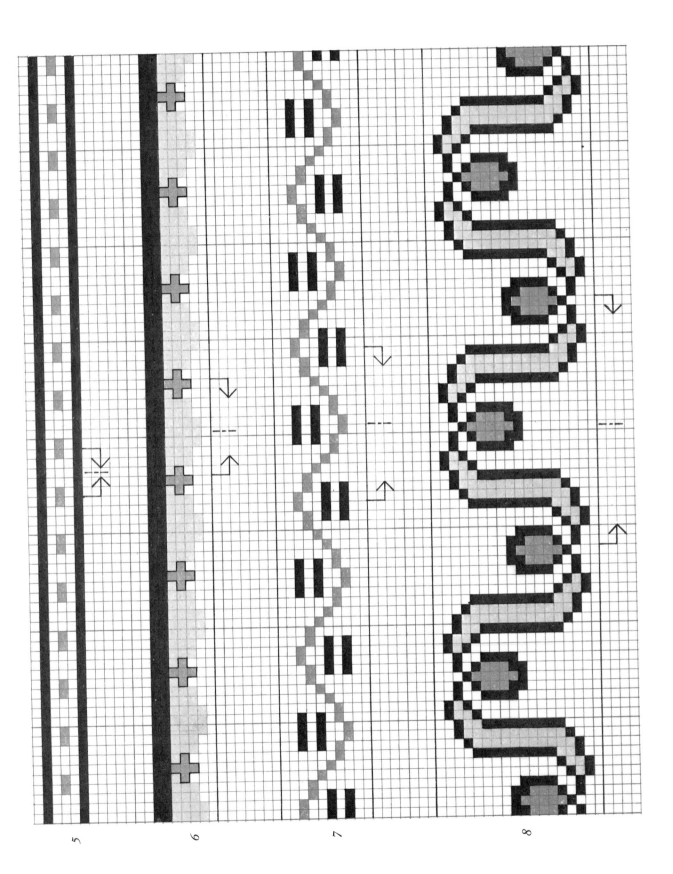

5
6
7
8

5. 5 stitches wide

Canvas Gauge	Approximate Width
#18	¼ inch
#14	⅜ inch
#10	½ inch
#5	1 inch

6. 7 stitches wide

Canvas Gauge	Approximate Width
#18	¾ inch
#14	½ inch
#10	¾ inch
#5	1½ inches

7. 10 stitches wide

Canvas Gauge	Approximate Width
#18	½ inch
#14	¾ inch
#10	1 inch
#5	2 inches

8. 18 stitches wide

Canvas Gauge	Approximate Width
#18	1 inch
#14	1¼ inches
#10	1¾ inches
#5	3½ inches

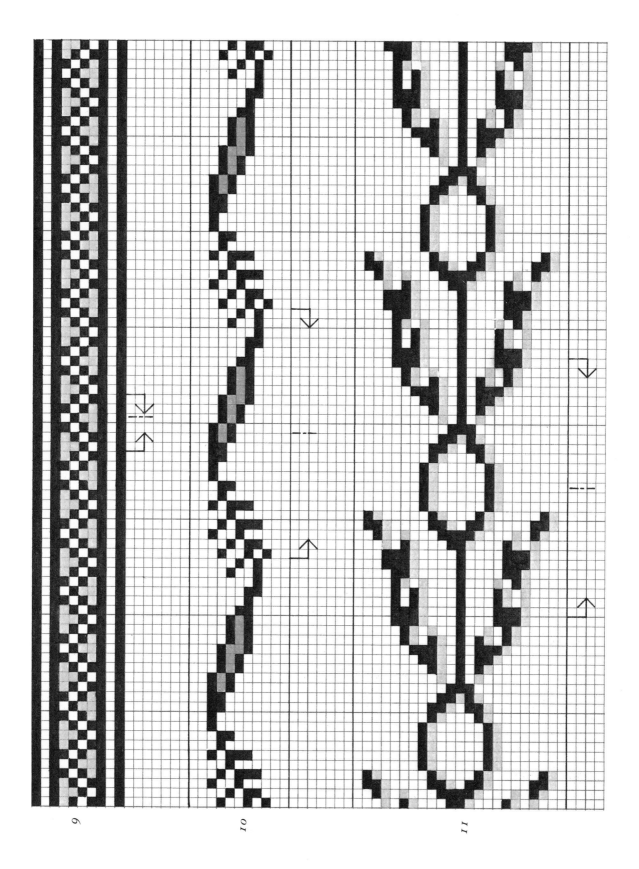

9 10 11

9. 10 stitches wide

Canvas Gauge	Approximate Width
#18	½ inch
#14	¾ inch
#10	1 inch
#5	2 inches

10. 12 stitches wide

Canvas Gauge	Approximate Width
#18	⅝ inch
#14	⅞ inch
#10	1⅛ inches
#5	2¼ inches

11. 23 stitches wide

Canvas Gauge	Approximate Width
#18	1¼ inches
#14	1⅝ inches
#10	2¼ inches
#5	4½ inches

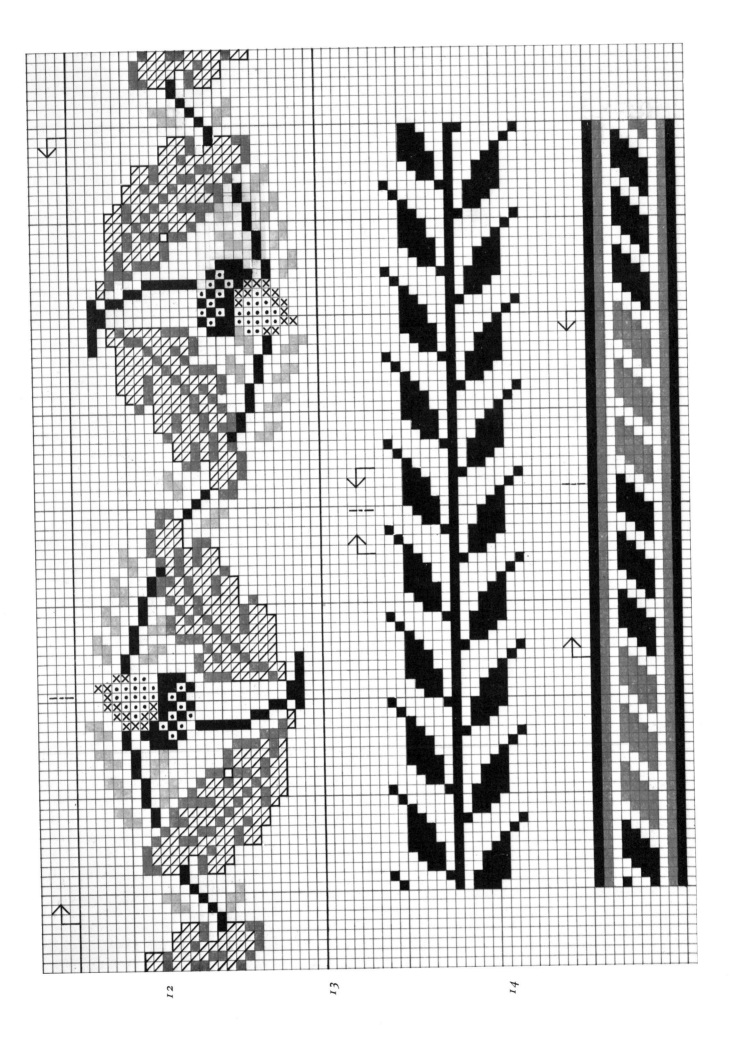

12

13

14

12. 10 stitches wide

Canvas Gauge	Approximate Width
#18	½ inch
#14	¾ inch
#10	1 inch
#5	2 inches

13. 15 stitches wide

Canvas Gauge	Approximate Width
#18	⅞ inch
#14	1⅛ inches
#10	1½ inches
#5	3 inches

14. 27 stitches wide

Canvas Gauge	Approximate Width
#18	1½ inches
#14	1⅞ inches
#10	2⅝ inches
#5	5½ inches